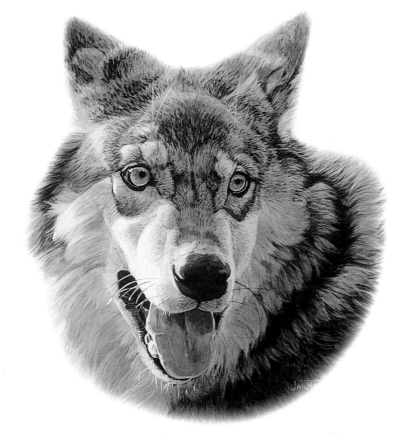

Wildlife

PAINTING BASICS

WOLVES, FOXES *& COYOTES*

Acrylic and Chromacolour on Masonite
8" × 10" (20cm × 25cm)
Collection of Pete and Marlene Luitwieler
—Autumn Maples–Young Wolf (Detail)—

Wildlife

PAINTING BASICS

WOLVES, FOXES & COYOTES

Jan Martin McGuire

NORTH LIGHT BOOKS
CINCINNATI, OHIO
www.artistsnetwork.com

Rocky Realm (Detail)
Acrylic on Masonite
14" × 17" (36cm × 43cm)
Collection of Dan and Helen Senkiewicz

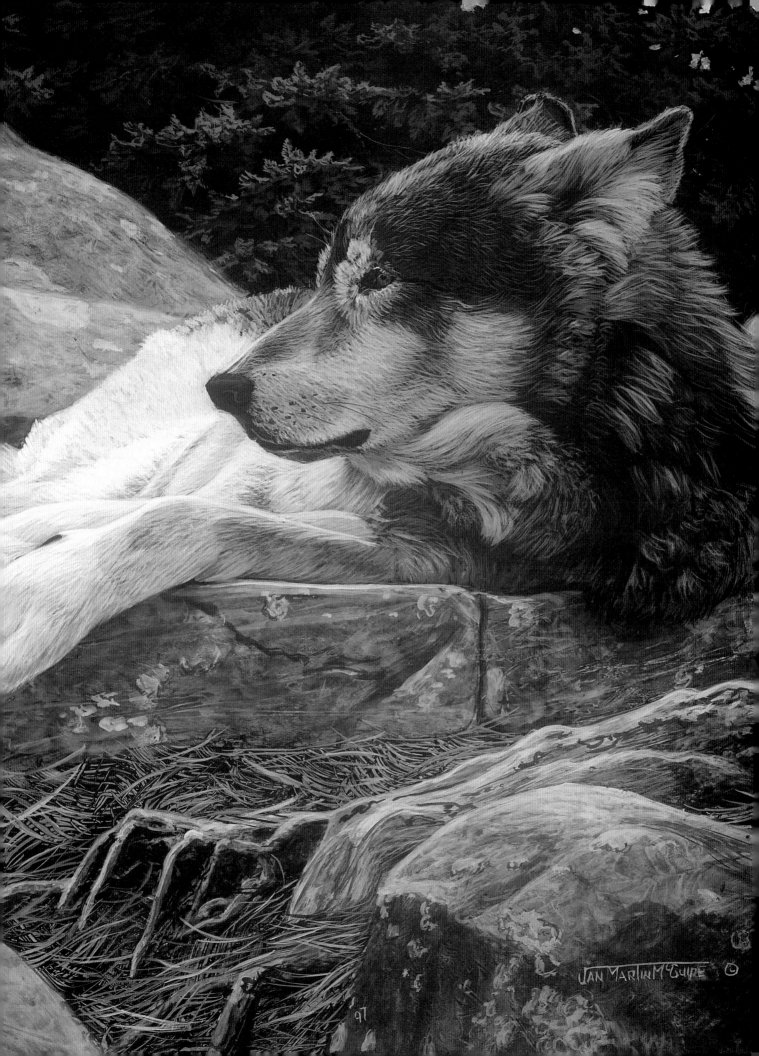

DEDICATION

I would like to dedicate this book to the four most important people in my life.

First, to my wonderful business and life partner, James Gary Hines II. Without the strong environment of patience, love, encouragement and support he has woven around me, I would not be who I am today.

Second, to my wonderful daughter, Teal, whose sense of humor, sunny outlook and uncritical acceptance of her "weird artist mom" are a constant joy in my life.

And last, to my dearly missed parents, who encouraged me in my art and allowed this little tomboy to be who she was, boxes of snakes in the garage and all!

ACKNOWLEDGMENTS

To Mary Agnew, the best friend anyone could ever have. She has always been there with valuable advice and needed encouragement along my life and career paths.

To Mary's fantastic artist husband, Al Agnew. My constant fear of his criticism sat heavy on my shoulders while working on the book, keeping me ever on the straight and narrow and causing me to produce the best book on painting wolves I possibly could.

To Craig Sholley and Lisa Stevens, my expert consultants on nature who happily try to answer any bizarre question I may come up with.

To Frank Sisser, publisher of *U.S. Art* magazine, for all his advice and help with my career decisions.

To Alan Hunt, John Seerey-Lester and Robert Bateman, for making me a better artist.

To Dr. Erich Klinghammer, for his dedication to education about wolves.

To Pete and Marlene Luitwieler and also Nancy Spencer, for continued friendship and belief in me.

To my editors at North Light Books, Rachel Wolf, Marilyn Daiker, Nancy Lytle and Stefanie Laufersweiler, who helped me to fulfill one of my career goals of writing a book.

To all my many collectors, whose shared love of nature and wildlife and continued support of my work have allowed me to make a living with what I love doing. I can't imagine a better life. Thank you.

Wildlife Painting Basics: Wolves, Foxes & Coyotes. Copyright © 2001 by Jan Martin McGuire. Manufactured in China. All rights reserved. No part of this book may be reproduced in any form or by any electronic or mechanical means including information storage and retrieval systems without permission in writing from the publisher, except by a reviewer, who may quote brief passages in a review. Published by North Light Books, an imprint of F&W Publications, Inc., 1507 Dana Avenue, Cincinnati, Ohio 45207. (800) 289-0963. First edition.

Other fine North Light Books are available from your local bookstore, art supply store or direct from the publisher.

05 04 03 02 01 5 4 3 2 1

Library of Congress Cataloging-in-Publication Data
McGuire, Jan Martin.
 Wildlife painting basics: wolves, foxes and coyotes / by Jan Martin McGuire.
 p. cm.
 Includes bibliographical references and index.
 ISBN 1-58180-051-7 (pbk. : alk. paper)
 1. Wildlife painting—Technique. 2. Wolves in art. 3. Foxes in art. 4. Coyotes in art. I. Title: Wolves, foxes and coyotes. II. Title.

ND 1380 .M37 2001
751.45'432—dc21 2001030487
 CIP

Editor: Marilyn Daiker
Production editors: Nancy Lytle and Stefanie Laufersweiler
Designer: Lisa Buchanan
Layout artist: Donna Cozatchy
Cover designer: Joanna Detz
Production coordinator: Kristen D. Heller

METRIC CONVERSION CHART

to convert	to	multiply by
Inches	Centimeters	2.54
Centimeters	Inches	0.4
Feet	Centimeters	30.5
Centimeters	Feet	0.03
Yards	Meters	0.9
Meters	Yards	1.1
Sq. Inches	Sq. Centimeters	6.45
Sq. Centimeters	Sq. Inches	0.16
Sq. Feet	Sq. Meters	0.09
Sq. Meters	Sq. Feet	10.8
Sq. Yards	Sq. Meters	0.8
Sq. Meters	Sq. Yards	1.2
Pounds	Kilograms	0.45
Kilograms	Pounds	2.2
Ounces	Grams	28.4
Grams	Ounces	0.04

Author and artist Jan Martin McGuire with "Orca," a timber wolf at a research facility.

Known as an artist and naturalist who paints nature's diversity, Jan Martin McGuire was born in the foothills of the Colorado Rockies. An inveterate tomboy, she spent her days climbing trees, catching snakes and drawing the animals she loved. After moving to Oklahoma in her teens, she majored in fine art at the University of Tulsa. She has studied with many of the world's top wildlife artists, including Robert Bateman, John Seerey-Lester, Carl Brenders and Alan Hunt.

Jan is uniquely qualified to write this book on painting wolves, foxes and coyotes as she has studied them extensively. She has owned a red fox as a pet and currently has a rescued wolf-malamute hybrid. She was invited to be one of the first participants in the International Wolf Center's "Wolf Weekends." During this adventure, the group located wolves by their radio collars from a small plane, then cross-country skied, snowshoed and dogsledded into remote areas of Superior National Forest in their quest of the animals. Jan has also worked closely with Wolf Park, a research facility in Indiana, furthering her knowledge of wolves and coyotes.

Working in acrylic and Chroma-colour paint on smooth Masonite panels, Jan creates the fine details, textures and lighting that are hallmarks of her work. Manipulating the paint on the board with her brushes, sponges and cellophane, Jan creates lifelike renderings of fur, feathers, mosses and rocks. The surrounding habitat is always scientifically correct, yet an artistic backdrop to the main subject of the wildlife species she is depicting.

Jan is a member of the exclusive Society of Animal Artists and has had her work displayed in the Smithsonian Institution, the Gilcrease Museum and the London Natural History Museum. Her paintings have appeared in numerous magazines, including *National Wildlife Federation, U.S. Art, American Artist, Watercolor Magazine* and *Wildlife Art Magazine*. Jan's paintings are also included in North Light Books' *The Best of Wildlife Art, Best of Wildlife Art 2* and *Keys to Painting: Fur & Feathers.*

Jan has one daughter, Teal, and currently lives in the Osage Hills of Oklahoma. She shares her life with her partner, James Gary Hines II, who manages the business aspects of her career. They share their home with a large menagerie of pets.

Wary Moment (Detail)
Acrylic on Masonite
16" × 8"
(41cm × 20cm)
Private collection

table of contents

foreword . . . *8*

introduction . . . *10*

CHAPTER ONE
Basics . . . 12

CHAPTER FIVE
Natural Habitat . . . 64

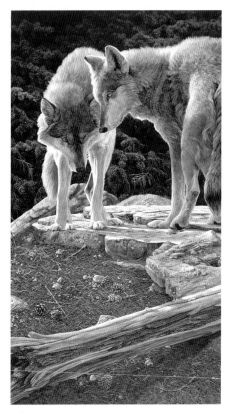

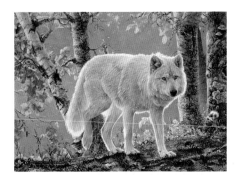

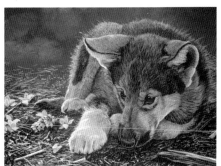

CHAPTER TWO
Anatomy and Proportions . . . 18

CHAPTER THREE
Pups . . . 48

CHAPTER FOUR
Attitude, Behavior and Movement . . . 52

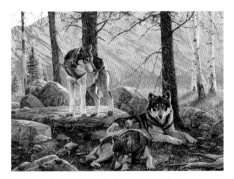

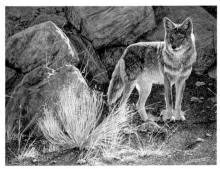

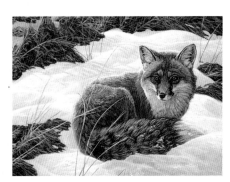

CHAPTER SIX
Painting a Pack of Wolves . . . 88

CHAPTER SEVEN
Painting a Coyote . . . 104

CHAPTER EIGHT
Painting a Red Fox . . . 114

appendix . . . 125

index . . . 127

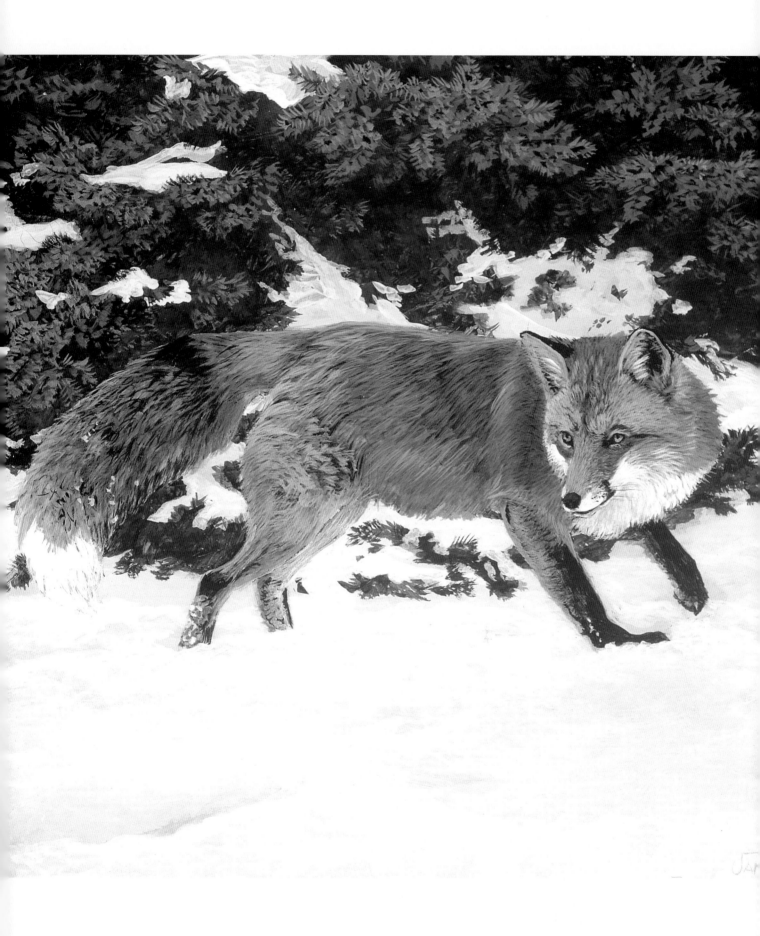

foreword

The Canidae, or dog family, has an ancient history in North America. Their oldest carnivore origins on the continent trace back almost 50 million years. A resourceful and adaptable nature ultimately brought ancestral wolves to scavenge around human settlements. This was the beginning of a human-canine partnership of over 12,000 years that endures to the present.

Jan Martin McGuire, a wildlife artist with an eye for detail, brings to life the North American members of the wild dog family. Jan combines her enthusiasm for all wildlife with a passion to depict her subjects accurately. Jan is always willing to go to great lengths to research not only anatomical relationships, but also behavioral and ecological details that are essential to the completed painting. Jan's accurate and inspiring images leave us to ponder whether this marvelous and ever resourceful group will continue to thrive, their future intertwined with our own.

Lisa Stevens, Senior Curator
Smithsonian Institution
National Zoological Park

Jan Martin McGuire has prepared this book to interest fellow artists in painting or drawing our wild North American members of the dog family: wolves, foxes and coyotes. An accomplished artist, she presents the biological basis of these animals from their anatomy to their behavior.

Those who paint or sketch animals have an advantage over photographers in that they can show the animals in suitable situations even though the observations may have been elsewhere. The author stresses the importance of observing animals in all possible situations. An artist who knows the animals well can impart something extra about the nature of the animal that goes beyond a technically accurate picture. I have no difficulty distinguishing pictures by artists who know the animals they have painted from those who merely paint portraits.

Artists have a unique role in introducing the general public to animals as they really are. An appreciation of these animals will hopefully contribute to public awareness that as fellow creatures with whom we share our planet, animals and their habitats need to be preserved.

Dr. Erich Klinghammer, Director
Eckhard H. Hess Institute of
Ethology and NAWPF-Wolf Park

Red Fox—Winter
Acrylic on Masonite
8'' × 10'' (20cm × 25cm)
Private collection

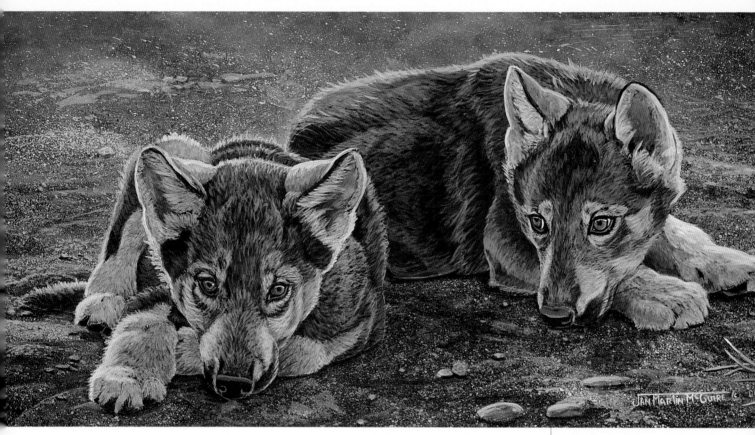

Moment in Time
Acrylic on Masonite
8" × 16" (20cm × 41cm)
Private collection

introduction

A mournful, plaintive call echoes off the Osage Hills in Oklahoma that I call home. Immediately it is answered, the sound coming from behind me. Soon the evening air is full of the song of what Native Americans call "God's Dog," the coyote. It's a wonderful and inspiring moment, one I have experienced many times but never tire of.

Our continent's wild canids, commonly called wild dogs—the wolf, fox and coyote—are favorite subjects of mine both from a naturalist's point of view as well as from an artist's. Why is it so inspiring to me? Well, besides the obvious beauty of the animal and the challenges associated with accurately painting its physical form, including its fur and eyes, there is a deep fascination with the animals themselves.

The wolf, with its strong family and social structure; the wily and clever coyote, who has adapted and expanded his range in spite of man and who is found only on the North American continent; and the beautiful and intelligent little fox, who is almost more catlike than doglike, inspire this fascination.

In this book, I will endeavor to excite you to paint these magnificent creatures along with me. I will teach you a little about their behaviors and attitudes, their anatomy and the habitats in which they are found. I will share with you the techniques I've developed over the years for painting not only the fur and eyes of these animals, but also techniques for painting their environment so that you can create a painting that is a true window on nature.

Although there are several species of both foxes and wolves, we will be focusing only on the red fox and the gray wolf (which is also called the timber wolf). If you are interested in depicting other foxes or wolves, these techniques can be adapted. You will have to do only a little research to be sure the anatomy of the animals and the habitats you are depicting are correct.

Research is paramount to creating realistic and correct wildlife art. It is best to do your own photography of habitats and animals whenever possible. In the appendix, I have listed zoos, research facilities, rescue organizations and other places where you can go to sketch and photograph wild canids. Recognizing that this is not always possible, I have also included places where artists may purchase reference pieces from professional photographers. If you work from published books and photographs, you must be aware of copyright laws. While it is OK to copy photos for your own use, it is illegal to copy these images to sell. It doesn't matter if you change the photo into a painting or if you alter the background. If the image is at all recognizable to the general man on the street, you may be held liable.

If you must work from published photos, try to use the photos only as references. That is, combine different parts of the body from different photos to make your own unique animal. Watch out for light sources, however! Remember there is only one sun for our planet, so be sure the light throughout your painting is coming from the same direction. The trick is to carefully observe the shadows, even if they are faint. Make sure all shadows are going the same direction.

But again, it's so much better when, as an artist, you can observe and understand the animal that you are endeavoring to depict, and to experience the habitat and environments that are home to your subjects.

So pick up a brush and come along with me into the fascinating world of North America's wild dogs!

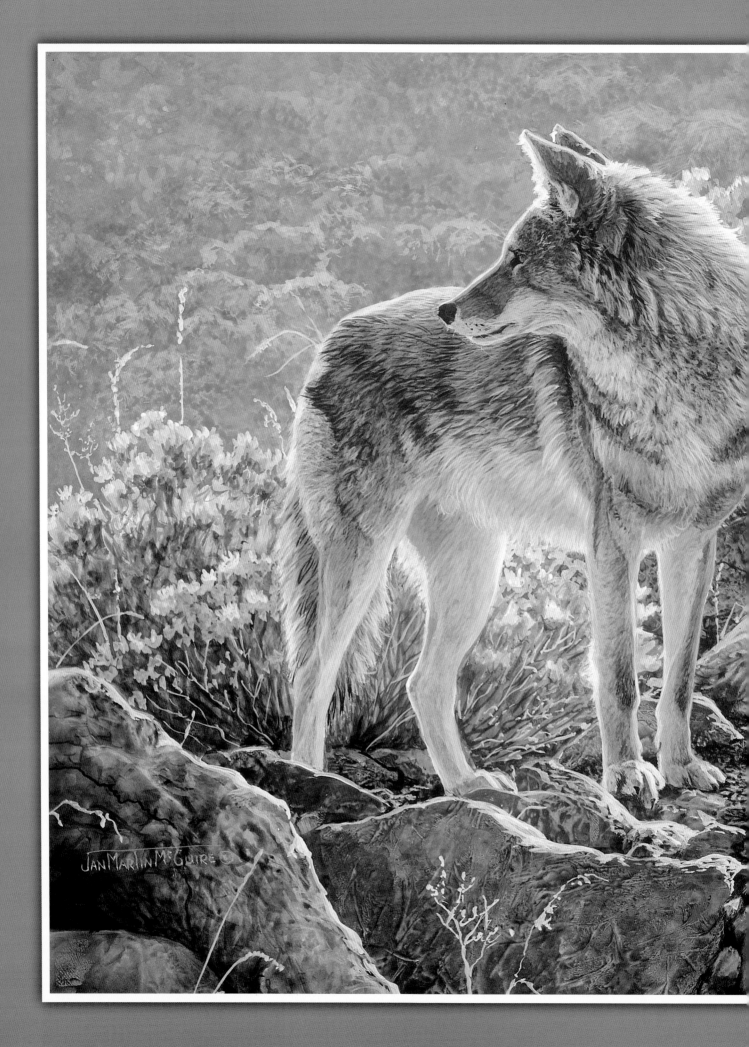

1

BASICS

To best help you achieve the effects and techniques that I am going to show you in this book, let's start at the beginning. In this chapter, I will show you some very basic paint handling techniques and give you a list of my supplies. This doesn't mean you need to buy all of these items. It's just what I have in my studio and what I use most of the time. Many of the exciting things I will be showing you can be adapted to other mediums. As a matter of fact, many of the techniques I routinely employ are watercolor tricks that I have adapted to acrylics. Don't be afraid to experiment with the mediums you are familiar with to see what you can achieve.

Wild Domain—Coyote
Acrylic and Chromacolour on Masonite
8'' × 10'' (20cm × 25cm)
Collection of Mark Borla

Paints and Brushes

Acrylics and Chromacolours

I use acrylic and Chromacolour paints in all my paintings. I love the stiff body of the paint and the intense colors that help achieve the detail, luminosity and illusion of textures that I strive for in my work.

You may be asking yourself, "What are Chromacolours?" Chromacolours are a fairly new paint originally developed in England for the animation industry. They are extremely pigment-intensive, which takes a little getting used to for some artists. All that is required is to dilute them or, if necessary, tone them down with white. I use water to make them into beautiful, vibrant washes. They seem to retain the same color dry as when wet, which can be a problem with acrylics.

Chromacolours can be mixed with other water-based mediums, including acrylics, gouache and watercolor. If there is a color that you like better in the paints you are now using, or if you simply don't want to throw out all your old paints, you can easily add Chromacolours as you run out. I think you will soon find (as I did) that you prefer to paint with them almost exclusively. Drying time for Chromacolours is is slightly longer than for acrylics, which some people really like, and they dry to a softer, more velvety finish than acrylics.

The brand of acrylics I use is Liquitex. Some artists have very strong opinions about different brands of acrylic paint, almost to the point of snobbishness. I really have not found much difference from one brand to the other. Liquitex is readily available, has a wide range of colors and is relatively inexpensive, so that's what I use.

Because I use Chromacolours and acrylics interchangeably, hereafter whenever I refer to acrylics or paint, I am including Chromacolours unless otherwise indicated.

Jars vs. Tubes

I recommend buying paint in jars or pots rather than tubes. For the techniques I use, I prefer a free-flowing, smooth paint that is easy to mix and easy to apply. Tube paint contains a binder-type gel that makes it thick, gooey and hard to mix—otherwise it would simply run out of the tube.

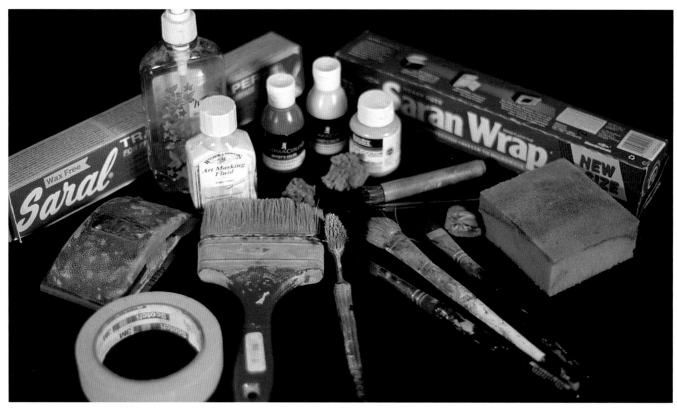

Materials Used
The two types and brands of paint that I use are Liquitex acrylics in 2 oz. jars and Chromacolours, a new British paint available from Canada by mail order, in 1.7 oz. pots. I prefer the more liquid and free-flowing paints found in jars and pots rather than the sticky gel-like paint found in tubes. Also shown here are many of the other items I use to create my paintings.

Make Your Subject Blend Into the Scene

Make Values Similar

Don't make the darks in your subject markedly darker than the surrounding habitat, and don't make the lights too much lighter. It's tempting to do this, hoping to make your subjects stand out, but it often makes them look cut out.

Repeat Shapes and Colors

Repeating shapes and colors throughout your painting helps to unify it. Bring surrounding colors subtly into your subject to blend it with its habitat. Repeating shapes also helps to achieve a harmonious composition.

Overlap Elements

Overlap elements within your composition, such as one subject behind or in front of another. Also bring habitat elements across and over each other, such as overlapping branches and grasses. This is especially important in making your subject part of the scene.

Create Lost and Found Edges

Don't make the edges around your subject too hard and obvious. Some areas should blend subtly into the surrounding background. Nature doesn't have any hard lines or dark straight edges around the outline of things. Creating lost and found edges will make your painting more realistic.

Look at Your Painting in a Mirror

Looking at your painting in reverse helps you see any elements that might need correcting or balancing.

Brushes

Some beginners get obsessed with the size and type of brush to use as well as with exact colors. I feel these concerns are irrelevant to creating great art. It takes time, experimentation and, most importantly, observation. I can tell you which supplies I use, but selection is very individual. With brushes especially, I am not too picky; I tend to pick up whatever is handy.

I mostly use round brushes with good points for detail work and finishing. When brushes become worn and frayed, they're great for scumbling in different textures. But I know wonderful artists who never use round brushes at all! The choice is up to you. The best advice I can give about brushes is to use the largest one you possibly can. Large brushes hold more paint, so you don't have to reload constantly; more importantly, they keep you from overworking your painting.

This is what I use in my studio on a regular basis. Finish reading the book, decide what you want to achieve and then you can either buy the materials that I used or try to adapt something you already have. I am not giving you strict recipes here, only hints, thoughts and ideas from my years of painting wildlife successfully full-time. Have a good time experimenting.

ART SUPPLIES

Chromacolour Paints
(available by mail order only, not in retail stores)
(888) 247-6621

Masterson's Sta-Wet Pro Palette
(available in many art supply stores)
(602) 263-6017

Funny Brush
(available from Lesnick Art Products)
(702) 736-6519

- Sketchbook for thumbnail ideas
- Mechanical pencil with .05 lead
- Kneaded eraser
- Masking tape and transparent tape
- Untempered Masonite cut to desired sizes
- Tracing paper
- Saral transfer paper (I use mostly the white)
- Masterson's Sta-Wet Pro Palette (great for keeping paint from drying out)
- Foam rubber sponges (like you find inside furniture cushions, cut to palm size)
- Winsor & Newton Art Masking Fluid for Watercolours
- Liquid hand soap
- Various Tupperware containers with lids
- Big wash brush (such as hake by Pro Art or Winsor & Newton gesso)
- Toothbrush
- Mop brush for watercolor (such as Winsor & Newton 240 no. 3)
- Funny Brush (by Lesnick)
- Loew-Cornell Series 7020 round brushes, various sizes from no. 2 to no. 14
- Loew-Cornell Series 7120 rake flats ¾-inch (20mm), ½-inch (13mm)

- Cellophane (such as SaranWrap)
- Natural sea sponges
- Handheld sander with wet/dry extra-fine 320 grit sandpaper
- Gloss varnish
- Chromacolour 1.7 oz. pots:
 - Burnt Umber*
 - Burnt Sienna*
 - Cadmium Orange Hue
 - Cadmium Red Medium Hue
 - Cadmium Yellow Deep Hue
 - Cadmium Yellow Medium Hue
 - Flesh Pink
 - Hooker's Green Hue*
 - Magenta Deep
 - Naphthol Crimson
 - Payne's Gray*
 - Phthalo Blue
 - Phthalo Green
 - Sap Green
 - Ultramarine Blue*
 - Unbleached Titanium White*
 - Yellow Ochre (also called Yellow Oxide)*
- Liquitex 2 oz. jars:
 - Burnt Umber*
 - Payne's Gray*
 - Raw Umber*
- Liquitex 16 oz. gesso (I use this as gesso and also for white)

Paints marked with * are the colors used most often.

Basic Paint Handling Techniques

There are many good books written on how to paint with acrylics, so I will not go into too much detail about the basics of painting. I will do a couple of quick demonstrations of some fundamental ways I use paint to create detail. As the book progresses, you will see how these very simple techniques are the foundation of all the effects I achieve.

One of the questions I am asked most often when talking about acrylics is, "How do I get them to dry slower?" The answer is, "You don't." Stop fighting the medium and use it to your advantage. I love to layer lots of thin washes, and I'm impatient even with acrylic's fast drying time, so I speed up the process with a hair dryer. It's pure joy to lay down washes of paint, one on top of the other, watching the colors shimmer and work with each other

without the worry of lifting up what you just laid down. Note: Chroma-colours will lift (pick back up) if you have thinned them quite a bit and then try to layer too soon. Use a hair dryer, but also give the paint a few extra minutes to set up. I do not use any extenders or other mediums, just pure water. Be sure to change your water often to get the truest, richest colors.

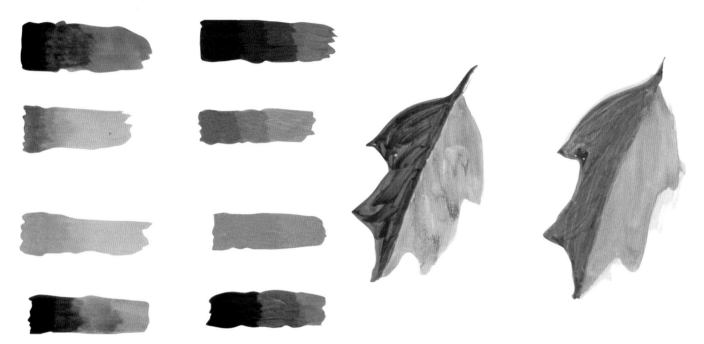

Pure Color Washes vs. Colors With Added White
I work with vibrant, pure color washes as much as possible. In the left-hand column are several examples of gradated washes, starting at left with the pure color opaquely applied, adding more water as you move to the right. In the right column are the same colors with white added. See how much more "dead" and flat they are? Look particularly at the second green and the second brown of each example.

Vibrant Overlapping Washes
Here I've painted two leaves using Hooker's Green. I have brushed a wash of Cadmium Yellow Deep Hue over the one on the right. I have allowed some of the color to go off the leaf so you can see what the pure color is like alone. Notice how the leaf suddenly becomes vibrant and alive. Always use clean water and brushes to achieve the purest washes.

Scumbling

Scumbling is a technique I often use. Take an old, worn round brush and squish it around in the mixed paint on your palette. Wipe off the excess, then squish, rub and roll the paint onto your painting surface. I really like the interesting texture it creates. I use this for clouds, ground cover and many other things.

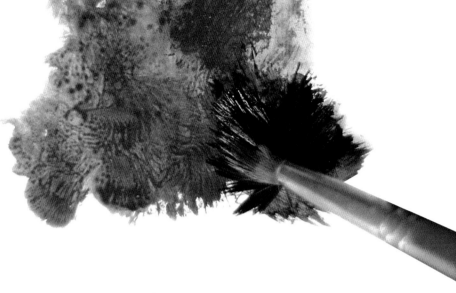

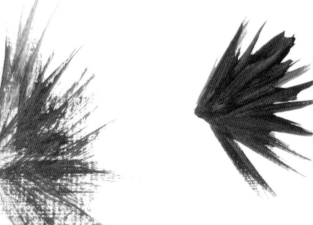

Drybrushing

Drybrushing is a technique where you put paint on your brush sparsely, with very little or no water, then drag your brush across the surface with light to medium pressure. I use this technique for creating wolf hair (more on this in chapter two). The example at left shows how drybrush looks. Using the same technique with a wet brush (above) obviously does not achieve the same effect. This is also an example of why I like a very smooth surface. Notice the horizontal- and vertical-lined texture in the drybrush example. This is because the gesso was not sanded smooth enough. I think this unwanted, added texture is distracting and hinders the illusion of real wolf fur.

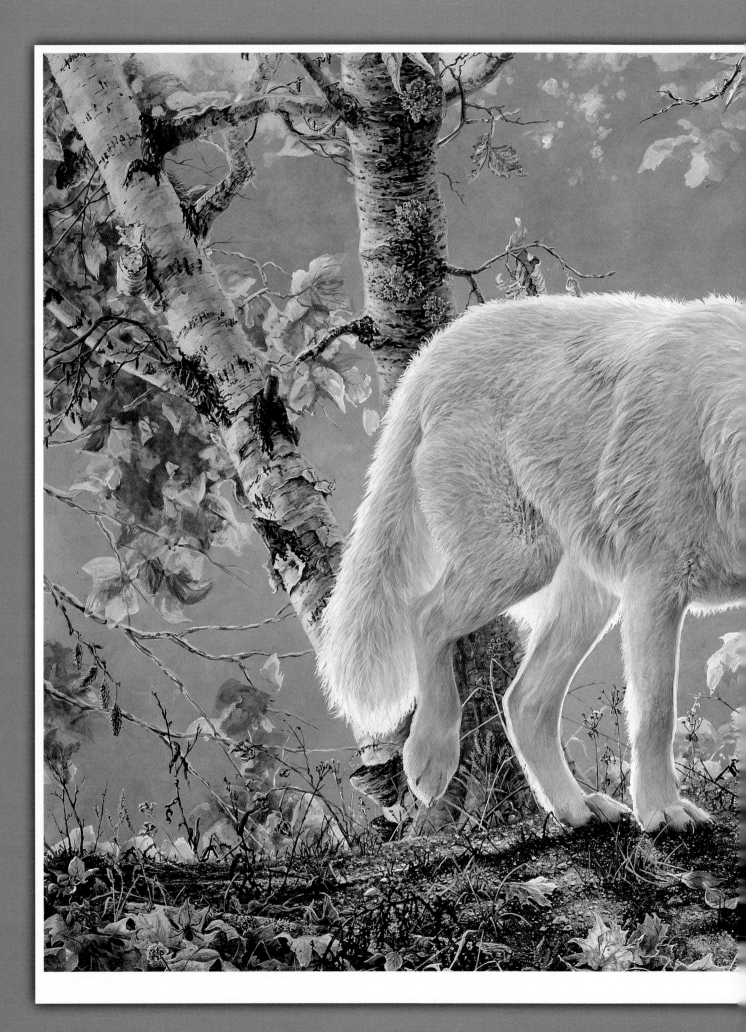

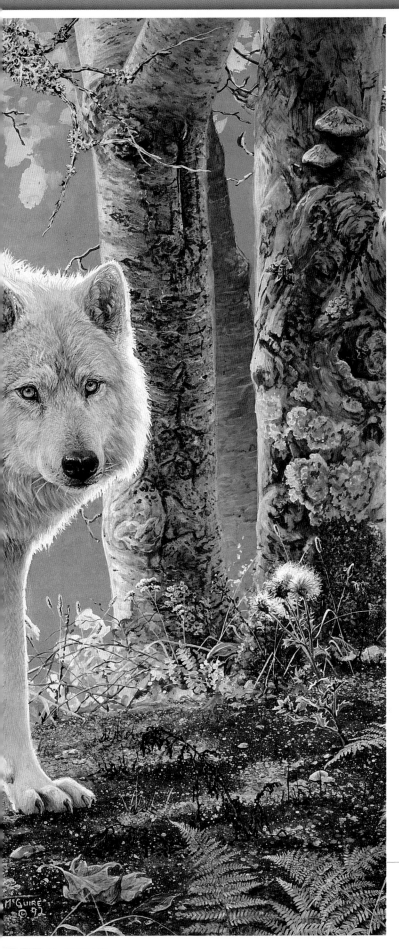

ANATOMY *and* PROPORTIONS

To paint nature well, you must understand all you can about your subject. The more you know, the more accurate, realistic and emotionally dynamic your painting will be. If you are excited about your subject, you will be able to create paintings that excite the viewer. Also, the people who enjoy and buy wildlife art tend to know about nature. It is in your best interest to understand it, too, and avoid making any potentially embarrassing mistakes!

In this chapter, we will explore some very basic anatomy such as bone and muscle structure and hair tracts. I will give you some pointers on rendering eyes, fur, noses, ears and paws. To help you understand these basics, I have included photos from my reference files of wolves, coyotes and foxes.

Autumn Glow
Acrylic on Masonite
18" × 24" (46cm × 61cm)
Collection of Dr. Marcia Fowler

What Is a Wild Canid?

What exactly are wild canids? *Canid* comes from the word *Canidae*, which, under the class Mammalia, is the family of wild dogs that we are discussing. There are some thirty-five species of wild dog worldwide. All have some specific common characteristics. Foremost, they have a very acute sense of sight, smell and hearing. They also stand upright on their toes (digitigrade) on four long legs. All canid paws have four toes on the rear paw and five toes with non-retractable, blunt claws on the front paw. The fifth toe is the dewclaw that does not touch the ground.

Their ears, which are used when listening for prey and in communicating with each other, are large, triangular and erect. Being hunters, wild dogs have eyes that are set forward on their faces to facilitate binocular vision, which helps them target their prey. Conversely, prey animals, such as deer, have their eyes on the sides of their heads, which gives them a wider range of view for watching for predators. The eyes of wild dogs are relatively large, clear, bright and intelligent. Their noses are large and moist, and their muzzles are long to help them gather in the scent of their prey.

Wild dogs do not hunt by stealth, crouching low to the ground as cats do. Their legs are long for running distances to catch their dinner. Their claws are used for traction in running and, thus, are not retractable. Tails tend to be bushy on all wild dogs. The theory is that the tail is used quite extensively in communication with each other, and being bushy helps to draw attention to it.

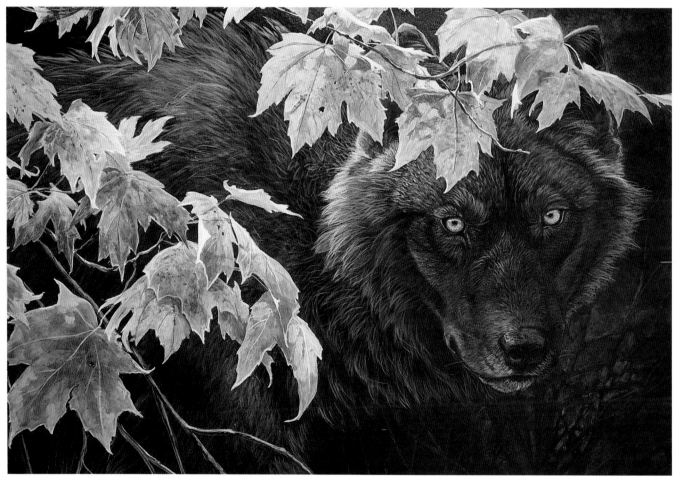

Autumn Encounter
Acrylic on Masonite
20" × 24" (51cm × 61cm)
Collection of Scott and Elaine Taylor

Wild canids are the wild cousins of our domestic dog. All members of the dog family have several characteristics in common, including an incredible sense of smell and very sharp eyesight.

Importance of Drawing From Life

Drawing is the most important technical skill an artist needs to master. You can paint if you can draw, but you can't paint if you can't draw. Drawing is basically hand and eye coordination. Practice makes perfect, so it is important to sketch and draw as much as you possibly can. Practicing by sketching from photographs is good, but it's much better to learn to see three-dimensionally by sketching from life. In the appendix, you will find lists of zoos and research facilities where you can go to study wolves. By all means take along a camera, but also take a sketchbook. Remember that these are training exercises that help get the essence of your subject into that computer of yours: your brain.

Basic Tools for Sketching in the Field

Hardbound sketchbook
Mechanical pencil 2H
 .05mm size lead
Extra lead
Rubber bands to hold
 pages open
Kneaded rubber eraser

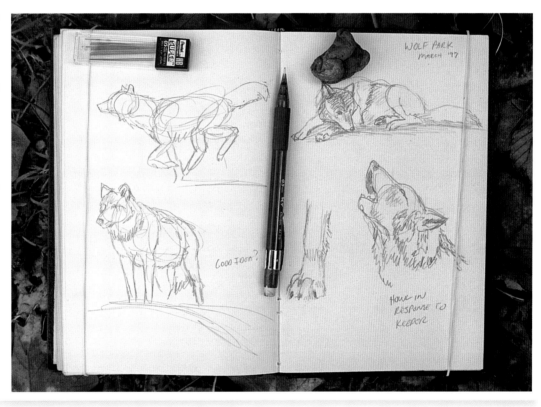

Basic Drawing Techniques

The best way to start a sketch, especially when you are working quickly in the field, is to divide your subject into shapes, such as circles, cylinders and ovals. This will help you get the proportions correct. Draw very lightly to start off. I've drawn the examples below much darker than I would in my sketchbook. I have also made the sketches more clearly defined so that you can see what I'm talking about. In the field these sketches would be very quick and crude circles, ovals and bean shapes. If you try to draw an outline of your subject—particularly if it is moving—it will be out of proportion, with the head too big for the body or vice versa. Instead, move from one sketch to another as the animal moves. You don't have to complete every sketch you begin. Believe it or not, just looking at these tentative starts later will trigger your memory as to what you saw that day. If the animal moves back into a similar position, you can finish the sketch by adding the outline of the fur. If it holds still long enough, you can add eyes and other details, but capturing the essence is all you really need.

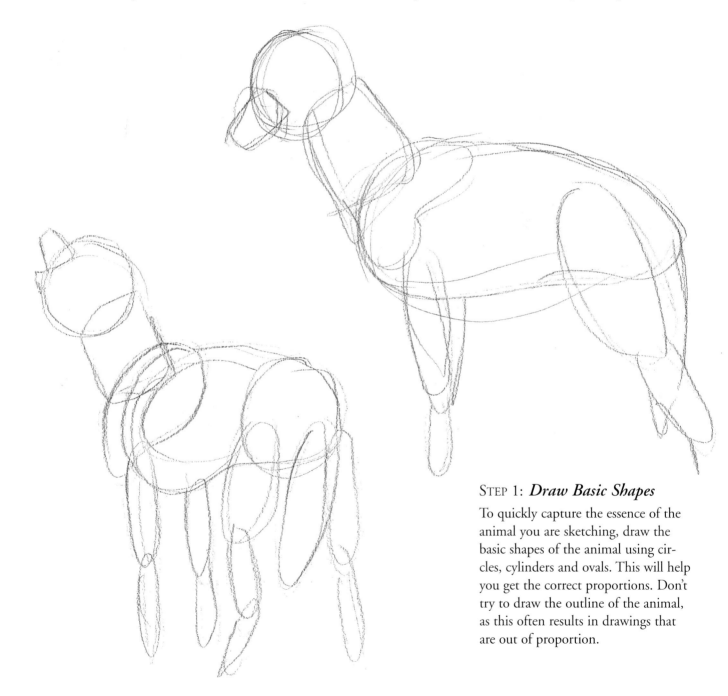

STEP 1: *Draw Basic Shapes*
To quickly capture the essence of the animal you are sketching, draw the basic shapes of the animal using circles, cylinders and ovals. This will help you get the correct proportions. Don't try to draw the outline of the animal, as this often results in drawings that are out of proportion.

STEP 2: *Create Fur Outline*

Keep working back into your drawing by creating the outline of the fur around the animal. If you are working from a live animal, start new drawings as it moves. Usually it will move back into the pose or poses you have already started and you can then refine your sketches.

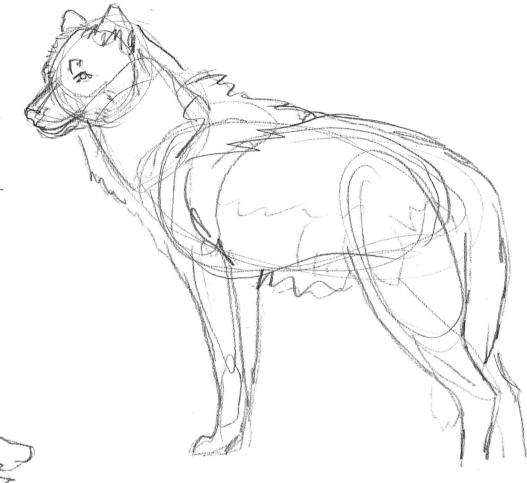

STEP 3: *Sketch Details*

Add details, such as eyes, ears and fur, until you have a completed sketch you are satisfied with. Remember, even simple drawings done with ovals and circles will trigger your memory of what the animal looked like.

Anatomy

You may ask why you need to be concerned about the inside of the animal when you intend to paint only the outside. It's like the foundation and framework of a house: Although you don't see them when you are looking at a completed house, they must be there or the house would collapse. It's the same when painting animals. You must have a basic understanding of what is happening underneath the skin so that you can create an animal that looks like it could really stand up and move—not like it's made of Jell-O.

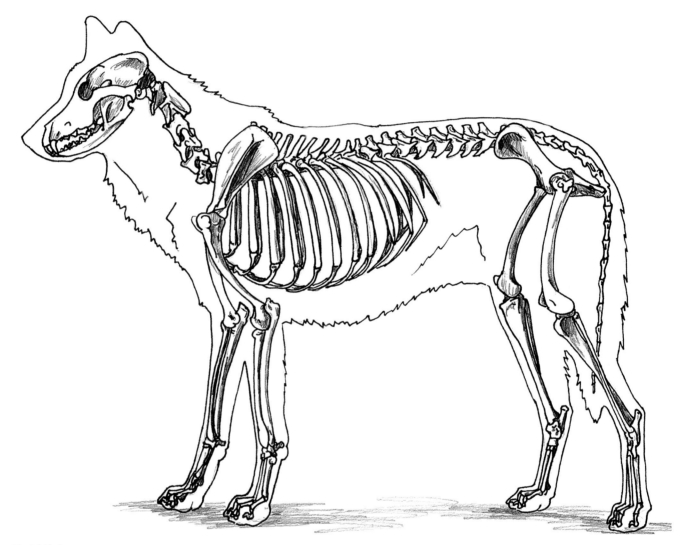

Canid Skeleton
This is the basic skeletal structure of all members of the dog family. It reflects the wild dog's basic running lifestyle: Note the long leg bones. The ribs are quite long, creating a deep chest to accommodate heart and lungs. The rigid structure of the vertebral column causes dogs to trot or gallop rather than bound like a cat. The long scapula (shoulder blade) contributes to the length of stride. Wild dogs are digitigrade, meaning that they walk on their toes. This also helps create long, graceful strides.

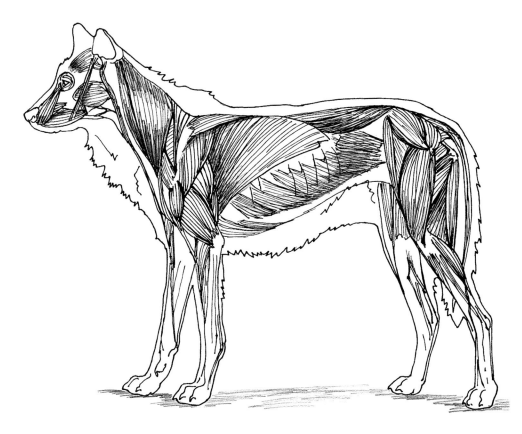

Canid Muscles
Some understanding of musculature is very important. Muscles tend to show under the skin, particularly on the legs and across the sides. Hair will break in areas where muscles bulge, such as over the shoulders.

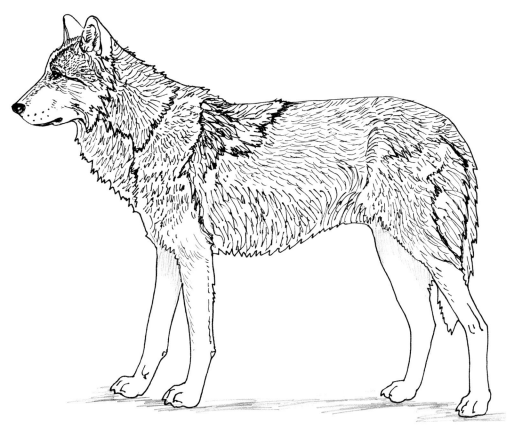

Basic Hair Tracts and Growth Direction
Hair grows in certain set patterns called hair tracts. It also grows in roughly the same direction on all animals. However, try not to create too neat a pattern of hair growth or your wild wolf will look like it has just come out of a dog-grooming salon. Notice the very short hair on the legs and face. The hair becomes longer on the cheeks and continues long down the neck, back and sides. Pay particular attention to the saddle area on the back. This longer, well-defined hair is very characteristic of wolves and coyotes but is not as noticeable in foxes.

Wolf Anatomy and Proportions

Latin name: *Canis lupus*
Length from nose to tail tip:
40" to 80" (100cm to 205cm)
Height from ground to top of shoulder: 26" to 38" (66cm to 97cm)
Weight: 57–130 lbs. (26–59kg)
Paws: front paws 4.5" long by 3.5" wide (11.5cm by 9.5cm)
Notes: Males tend to be larger than females
Coat description: Timber wolves, also called gray wolves, come in a variety of shades from pure white to pure black. The most common colors are buff, brown and shades of gray. Generally, the farther north wolves are found the lighter they are, but this is not always true. Wolves in one litter may vary from black to white. The arctic wolf is a timber wolf that has adapted to its environment by developing a white coat.

The wolf has a fuzzy, wooly undercoat with long (usually grizzled) guard hairs. During the summer, the wolf sheds this wooly undercoat along with some of the guard hairs, and the coat tends to look very moth-eaten. It is best to depict wolves in their thick, beautiful winter coats, but if you choose to paint your wolf with older puppies among summer flowers, then you must be accurate and portray it in its summer coat.

Differences Between Wolves and Coyotes

Wolves are much larger and more robust than coyotes.

Wolf muzzles are larger and more massive. Coyote muzzles tend to be more delicate and more sharply pointed.

Wolf ears are smaller than coyote ears.

Coyotes tend to have rounder, larger skulls.

Wolves tend to run with their tails held out, while coyotes run with their tails held down.

Differences Between Wolves and Wolf-Dog Hybrids

Wolf-dog hybrids are popular (but not recommended) pets in some areas. Many wolf rescue facilities end up having to give homes to abandoned animals. Be sure what you are studying is a purebred wolf.

On hybrids, ears tend to be smaller, more delicate, finer and more pointed, sometimes at an angle. Wolves have relatively short ears that are broad at the base and less pointed than those of most dogs.

Tails are almost always curled to some degree on hybrids and are usually carried higher. Wolf tails never curl.

Wolf eyes vary a great deal in color, but generally they are not dark brown, a shade often found in hybrids.

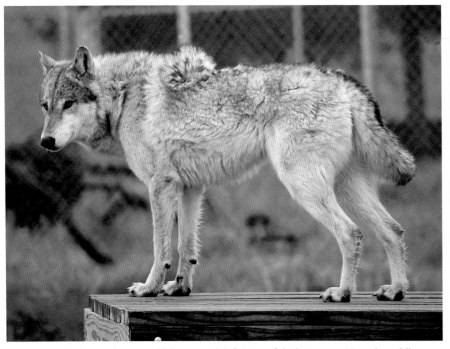

This photo of a brownish gray wolf shows good definition of the hair tracts. Note the saddle area that is blowing up in the wind. This saddle area becomes erect whenever the wolf is angry or frightened, making the wolf appear even larger. Note the shape of the legs; compare them to the skeleton on page 24 so that you can understand where the hocks and wrists bend. Note the pads on the wrist area above the dewclaw.

Reference Photos: Timber Wolves

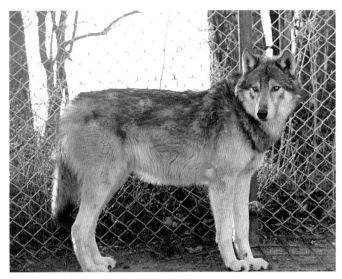

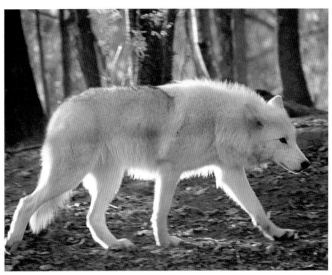

This is a nice, typically marked gray wolf. Notice the pattern on the face. Such patterns are distinctive, and scientists use these markings to identify individuals in the field. If you are creating a pack using limited references, be sure to adjust these markings or you'll end up painting a pack of clones. Notice how the hair on the stomach goes back toward the middle from the elbows, but forward toward the middle from the haunches.

Notice that this white timber wolf still has some black hairs along the saddle area and back. White wolves can be found in any litter or pack, but are more typical in the far northern areas of their range. White wolves can be tricky to paint. Look for subtle colors in the shadows—such as blues and violets—to help create form. This photo shows beautiful backlighting, with gold and peach reflected in the coat.

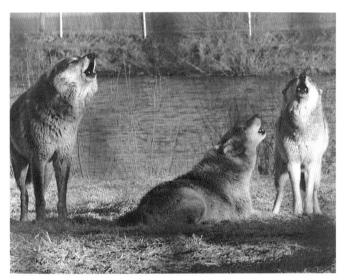

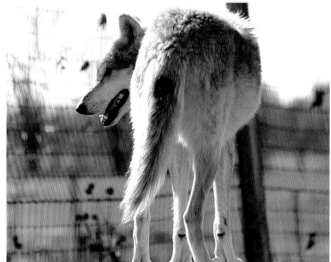

Generally, when one wolf in a pack starts howling, the whole pack joins in. Notice how they tend to purse their mouths rather than opening wide as coyotes do.

Look carefully at the shape of the legs in this rear view. Think about joints, tendons and muscles when you are painting, particularly in areas with short hair, such as the legs, where they are more noticeable. Also notice the black spot on the top part of the tail. A scent gland is located here, and there is almost always a black spot at the location.

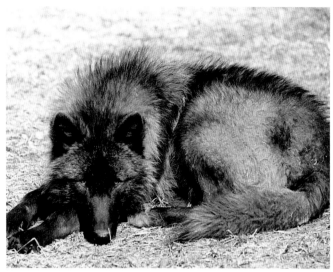

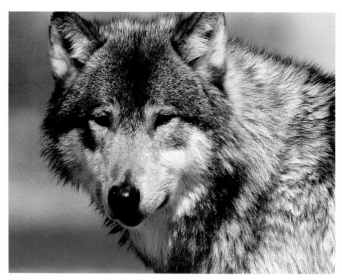

Notice the very light wool undercoat of this black wolf in a typical sleeping pose. Also notice the longer guard hairs that visibly stick up above the shoulder and down the back. Look at how the hair on the tail breaks into little sections. Don't try to paint every single hair—it won't look realistic. Paint groupings of hair.

Notice how the hair on the face varies in length. It starts very short at the nose and mouth, gradually getting longer on the forehead. The forehead hair sort of pokes up and out. At the cheeks, neck and throat, the hair becomes progressively longer. Also look at the indentation with two ridges on either side where the muzzle begins after the nose. Be sure to paint highlights on the nose. Canids' noses are always wet.

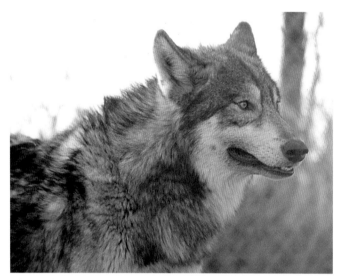

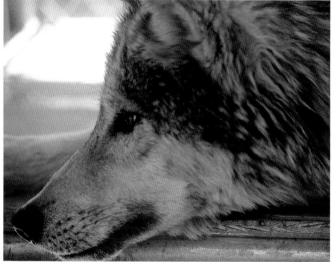

This wolf has the typical gray mask that many timber wolves sport. With these markings, the throat, neck and muzzle generally will be white. This photo also shows the hair tracts on the neck and shoulder very well.

When looking at the eye from the side, you can see the sclera (white part of eye). Notice how the iris and pupil are oval from this angle. Also notice the black dots where the whiskers—yes, wolves have whiskers—come out of the muzzle.

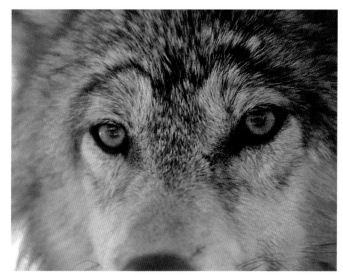

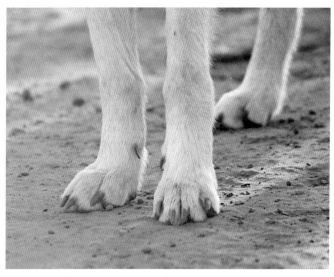

Wolves have very expressive faces, resulting from intelligent eyes and highlighted by the eyebrows. This picture shows the swirled areas of fur at the top inside area over the eye. A darker line of hair almost always surrounds these swirls.

The wolf has four toes on the back feet and four toes touching the ground on the front feet. The fifth toe is the dewclaw that does not touch the ground. This close-up of the front feet clearly shows the dewclaws located high on the front legs. Dewclaws are sharper because they don't touch the ground.

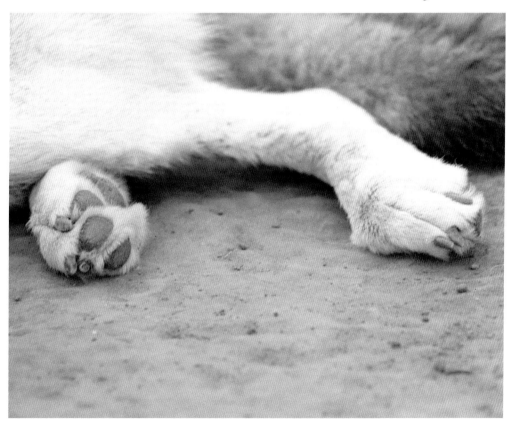

Notice the long hair between the pads on the feet, as well as the shapes of the pads. If you are having trouble with feet, look at a dog's feet. All canid feet are similar, but shepherds, huskies and malamutes are the closest to wolves in all parts of their anatomy.

Coyote Anatomy and Proportions

Latin name: *Canis latrans*
Length from nose to tail tip:
41" to 52" (105cm to 132cm)
Height: 23" to 26" (58cm to 66cm)
Weight: 20–40 lbs. (9–18 kg)
Notes: Males tend to be larger than females; eastern races tend to be larger than western races

Coat description: Coyotes are generally grayish to brownish. The coats are not a uniform solid color, however. There are always highlights and darker guard hairs throughout the coat, with the belly, throat and legs tending to appear whitish. Most tend to have varying degrees of a rufous rust color on their muzzles, legs and backs of their ears. Northern coyotes tend to be larger, thicker furred and lighter in color than their southern counterparts. Eastern specimens also tend to be darker than western. Tails almost always have a black tip.

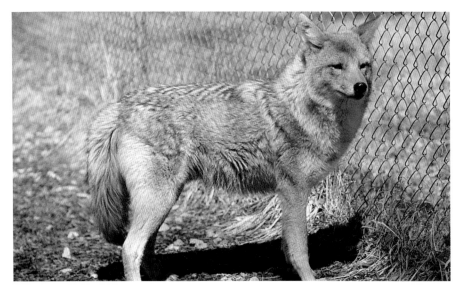

Coyotes are generally an overall gray-brown in color. However, they all have subtle variations in coat color from one individual to another. Northern coyotes tend to be lighter than their southern counterparts. Most coyotes have rust on the muzzle, ears and legs. Coyotes tend to have very bushy tails that are held low.

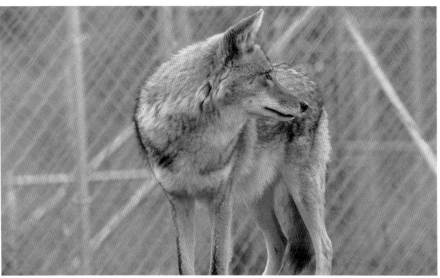

This photo clearly shows the finer, pointed muzzle and larger ears that coyotes have compared to wolves. Also notice the black lines on the front of the legs. This seems to be a very common trait. This coat color is very typical, containing lots of rusts and browns.

Reference Photos: Coyotes

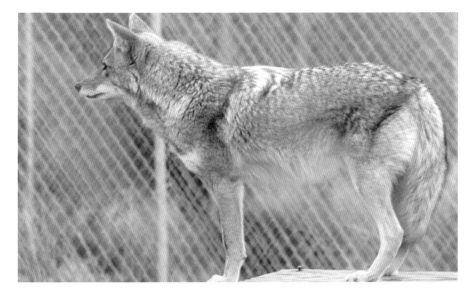

Take note of the obvious hair tracts on the neck, shoulders, stomach and haunches of this beautifully marked coyote. This coyote is probably a little on the heavy side since he is in captivity. You must be careful when using captive animals as references. Be sure not to make them too fat, and make sure the coat looks rough enough. Life in the wild can be hard.

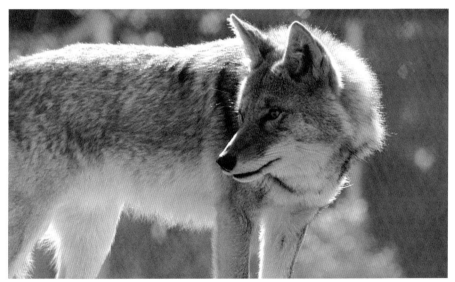

This picture is a great example of the large ears of coyotes. Coyotes hunt for mice and voles in thick grass and under snow. The ears are used to listen for the telltale rustling of their prey. Observe how the hair sticks out from the neck where the hair tracts meet.

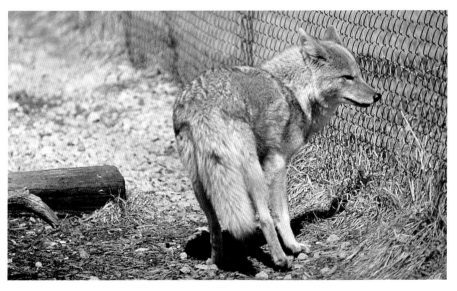

Notice on this rear view of a coyote the black spot on the tail where the scent gland is located. Also notice the black tip on the tail, which is fairly consistent in all coyotes.

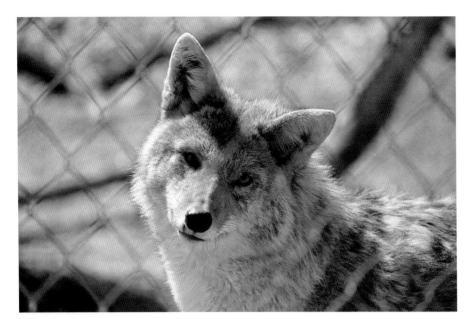

This photo typifies the curious, intelligent face of the coyote. Painting muzzles head-on can be tricky because of foreshortening. Carefully observe the angles where the muzzle connects to the face.

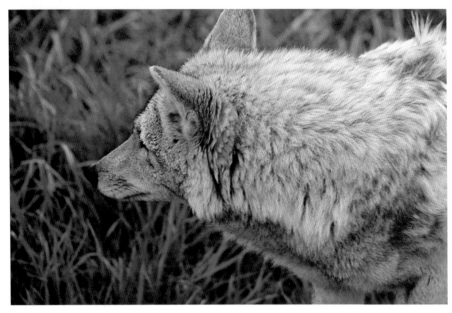

Look carefully at how the hair parts into little V's around the base of the ears. Think about being able to put your fingers into the hair. Look for shadows and parts within the fur to help add depth.

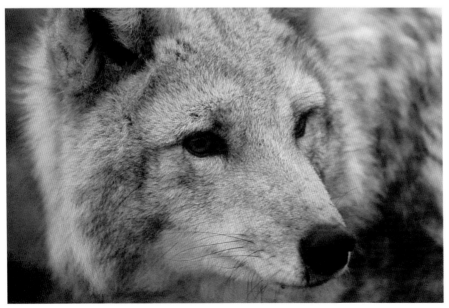

Notice that the hair, which is short on the muzzle, gets longer on the forehead and much longer on the cheeks. Also notice the fine, delicate whiskers. Be sure to include the eyebrow areas above the eyes to give form and expression to the face. Coyotes typically have copper-colored eyes.

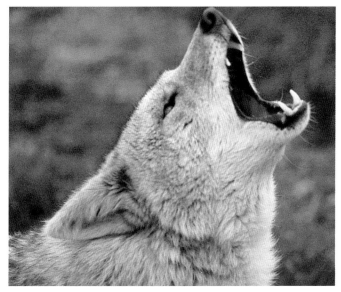

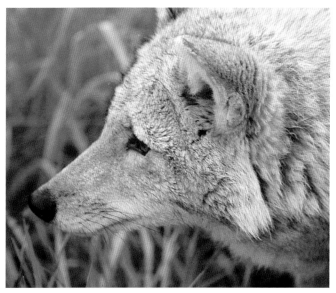

When they howl, coyotes tend to throw their heads way back, pointing their muzzles straight up and opening their mouths more than wolves. Notice how the fur clumps under the cheeks. Look carefully at the nose. The nostrils aren't just round holes. There are slits down the sides that allow the animal's nose to expand to take in more scent.

Notice the rust ears and muzzle in this close-up of the hair details on the sides of the face. Pay attention to the shape of eyes from the side. Never let your brain tell you how something looks; really observe.

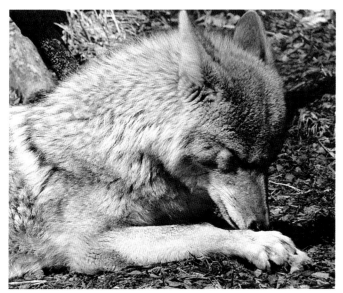

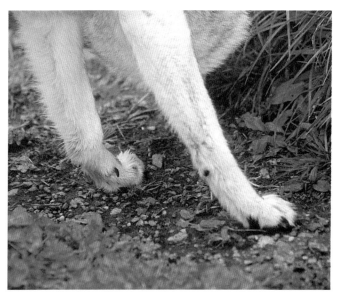

This is a good example of the high, rounded forehead of the coyote that dips down to the delicate muzzle. Observe how the hair on the forehead pokes straight up and out.

There is a pad on the backside of the leg above the dewclaw. This is where the wrist bone is located on the skeleton. The hair on the legs is short and tends to grow down and back.

Red Fox Anatomy and Proportions

Latin name: *Vulpes vulpes*
Length from nose to tail tip:
35" to 40" (90cm to 103cm)
Height from ground to shoulder:
15" to 16" (38cm to 41cm)
Weight: 7–15 lbs. (3–7kg)
Notes: Males only slightly larger than females; eyes are unique (the pupils are elliptical like those of a cat); carries bushy tail horizontal to ground
Coat description: The red fox comes in three different color phases. These colors are permanent, although they may vary at different times of the year. All three color phases may occur in the same litter. The most common is the *red phase*, which generally has a white throat and belly. Individuals in the red phase may range in color from pale tawny yellow to bright reddish orange. They generally have black legs and ears, and black on the sides of their muzzles. Generally, they have black guard hairs, particularly on the tail.

The two other color phases are *cross phase* and *silver* (sometimes called black) *phase*. These two color phases tend to occur more frequently in the northern parts of their range. I've seen lots of red foxes in Alaska, and they are almost always a cross or silver phase. The cross phase is reddish yellow to brown with dark guard hairs.

Generally, they are silver to black on their shoulders and back, creating a crosslike pattern. Silver (or black) phase generally has a black or brownish dark underfur, with silver-tipped guard hairs in varying degrees throughout the coat. All color phases usually have a white tip on the tail.

You may run across foxes in captivity with other colors that range from pale champagne and shimmering white to deep bluish black. These are genetically manipulated animals bred for the fur industry. The three color phases I have mentioned are the only true colors found in nature.

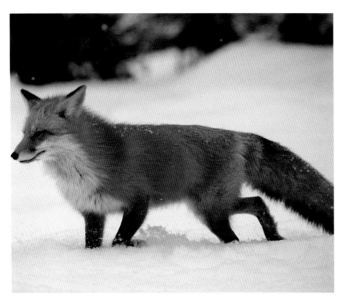

Red foxes come in a variety of shades. This one is a beautiful deep orange-red with a thick winter coat. Notice that the tail is covered with long black guard hairs. The tail is almost as long as the fox's body.

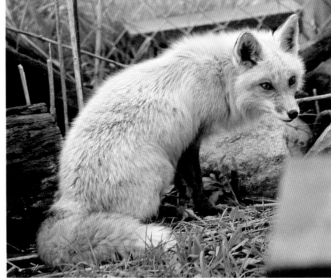

This example shows that a red fox can be a very light golden color. All red foxes have black legs and black patches on the muzzle and behind the ears no matter what their overall body color is. However, be aware that some foxes in captivity may have an unusual color not normally found in nature. Fur farms have genetically manipulated some very unusual color morphs (different color forms).

Reference Photos: Foxes

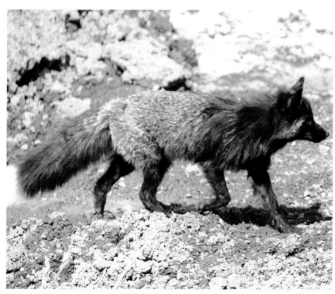

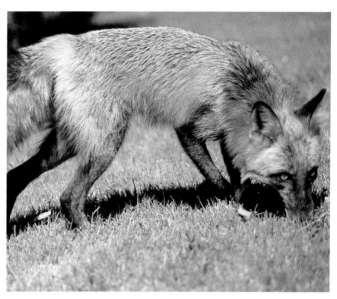

The silver (also called black) phase of the red fox is more common the farther north you go. All color phases usually have the white tip on the tail. Notice how the silver ticking starts halfway back. This seems to be typical no matter what the color phase.

This is the cross phase of the red fox. They typically have a reddish undercoat with black or silver fur across the shoulders and back in a cross pattern. They also have black legs, backs of ears and muzzle. Although it is perfectly accurate to paint these other color phases, most people equate a "red fox" with the stereotypical red color.

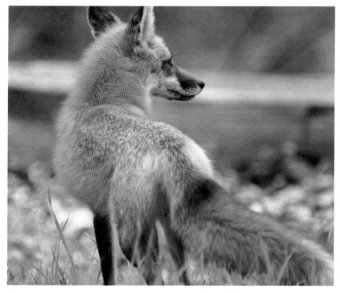

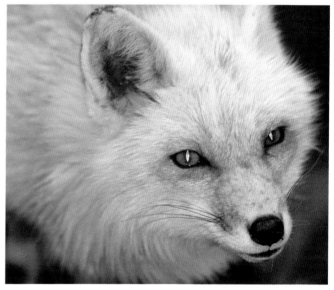

Foxes move in a very jaunty way, carrying the tail high. Notice that the grizzling on the back of most foxes starts about midway down the back.

A fox's pupils are elliptical like a cat's. Sometimes this is a little difficult to see in photos, so I set the flash on my camera to cause eye shine so that you could more clearly see their shape. However, you should paint pupils with a softer edge so they don't look like a caricature. (See the eye demonstration on pages 39-41).

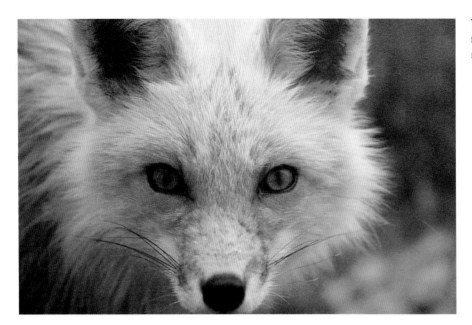

The hair is short on the muzzle, longer on the forehead and even longer on the cheeks. The nose is fairly dainty and small.

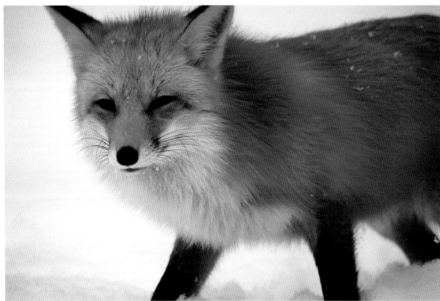

Notice the white markings under the chin, on the muzzle and down the neck and belly. These markings are not found on all foxes, but are very typical. Look at the Ultramarine Blue and Payne's Gray hues in the white under the chin and on the chest. Adding subtle colors when you paint will add depth and realism to your work.

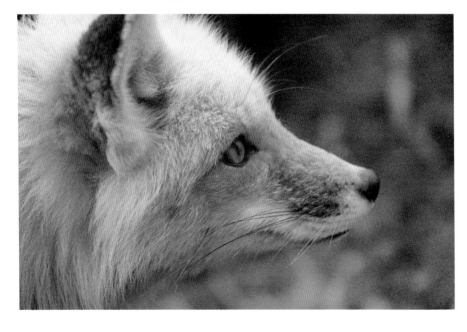

Observe how the shape of the eye changes to more of an oval when viewed from the side. Look carefully at the eyelids. See the subtle bluish reflection? Also notice the black patch on the muzzle and the long black whiskers.

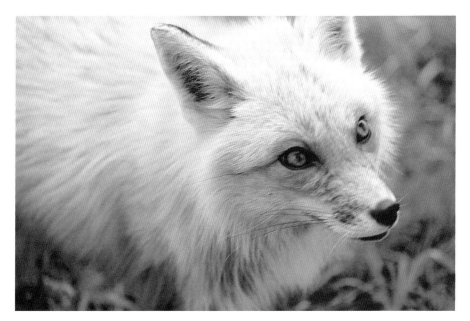

Notice how the light reflects off the rounded surface of the far eye in this view of the face. Look at the obvious hair tracts that meet to form a line out from the eye.

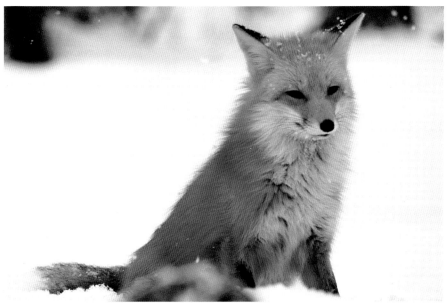

Fur tends to clump into V's and the hairs break away from each other at the points where muscles bunch, such as on this fox's shoulder. Look for these shadows to help you create depth and form.

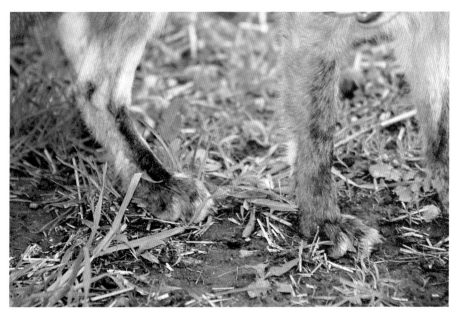

This close-up of a fox's feet shows that they are very small and delicate, with gently rounded toes. Sometimes the area is solid black. Other times, such as on this fox, there are lighter hairs mixed in. Many times the toes are white.

Eyes

It has been said that eyes are the windows to the soul, and I think there is a lot of truth to that. It certainly is what will create life in a wildlife painting. If the eyes are incorrect, lifeless, dull or flat, the whole painting will fall apart.

When painting eyes, try to look for how the eyelid casts a shadow. At times in bright light even the eyelashes will cast shadows. Canids' eyes don't stick out too far from the head as in other animals such as deer, so be careful not to overdo reflections.

Be careful when working from published photographs. Many times photographers use dual flashes that cause two white spots on the eyes. This is unnatural. Remember, we have only one sun, so you should paint only one bright spot—if you paint one at all. If it is an overcast day or if the eye is in shadow, there will be no bright white spot. Also, be careful not to place the spot in the center of the eye. This tends to make the animal look like it's blind. And don't make it too large for the same reason. Eyes will always have a blue or gray highlight (depending on the color of the sky) across the top. Observing and depicting this highlight will add that liquid reflecting look to the eye. This blue or gray, slightly curved highlight—not a bright white one—is the key to making a realistic eye.

Another trick to make an eye appear natural is to paint the highlighted color of the iris on the side opposite from the bright area of the sky reflection. It will be the same general color as the iris, just brighter and lighter.

Painted Examples of Canid Eyes

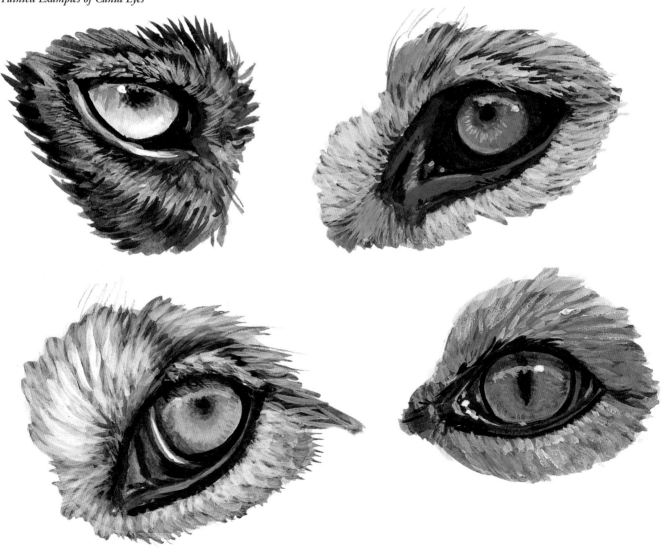

Pencil

No. 10 round brush
with a good point
(no old, frayed
brushes), or a
smaller brush
depending on the
size of the eye you
are painting

Gesso for white

Colors

Burnt Sienna

Burnt Umber

Magenta Deep (or a
similar warm vio-
let)

Payne's Gray

Ultramarine Blue

Yellow Ochre

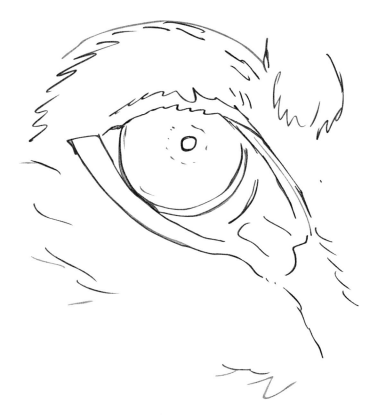

STEP 1: *Draw the Eye*

First, lightly draw the eye. Observe your reference careful-ly to see how the eyelid comes across the eye. Avoid a very round eye except on a puppy. This will give your animal a startled look.

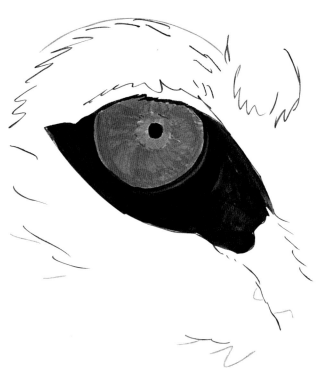

STEP 2: *Lay In the Basic Colors With Washes*

Mix Yellow Ochre with a small bit of Burnt Sienna. Add a nice medium wash to the rounded portion of the iris. Don't mix any white with this; white will dull and kill the vibrant color. As you paint, make your brushstrokes like the spokes of a wheel; not around and around the eye, but from the outer edge in toward the pupil. You can play with different colors to achieve different colored wolf eyes. Combinations to try include Yellow Ochre with a touch of Hooker's Green, Yellow Ochre with Cadmium Yellow, and Burnt Sienna with Burnt Umber.

Paint the dark shadow areas around the eye with Payne's Gray. Never use pure black. It is a dull, lifeless color that really does not exist in nature. Paint the pupil with Payne's Gray. For the outer eyelids, mix Burnt Umber, a little Payne's Gray and a touch of Magenta Deep. Paint the little bit of the sclera that is showing with white mixed with Payne's Gray.

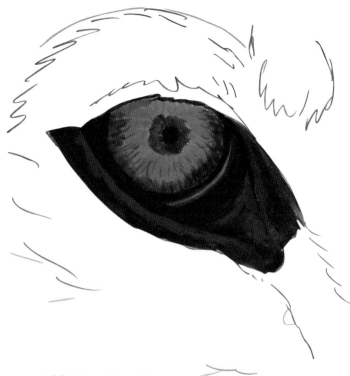

STEP 3: *Add More Details*

There is a rough, round area that surrounds the pupil. Paint this with a mixture of Burnt Umber, a little Payne's Gray and a very small amount of white. Then, using the same mixture you used for around the pupil, paint a rough brownish area around the outside of the eyes. Remember to use the wagon-wheel-spoke brushstrokes as used in step two. To soften this, add a light Burnt Umber wash over it.

Detail the eyelids more by using the same mixture you laid them in with—Payne's Gray, Burnt Umber and Magenta Deep—but this time add a little more white.

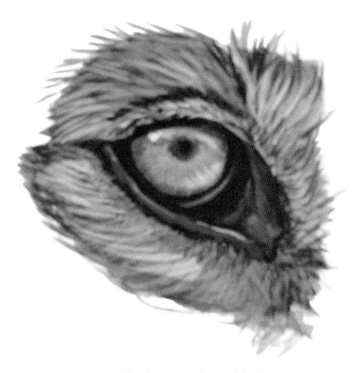

STEP 4: *Create Shadows and Highlights*

Shadows and highlights are the key to creating lifelike eyes. First, make the shadow that is being cast by the eyelid on the top of the eye. Use a mixture of Burnt Umber with Payne's Gray. Remember the eye is curved, so paint the shadow curved.

The second step is the most important. The eye will always reflect the sky in a gentle curved arch at the top of the eye. You must determine what the sky is like in your painting, even if it doesn't show. Is it a bright day with strong light and deep shadows on your wolves? Then you need a bright blue highlight. Is it a snowy, cloudy day without much shadow? Then make a gray highlight, and so forth. For this demonstration we will do a moderately overcast day.

Using clean water, mix Ultramarine Blue with just a touch of Payne's Gray and white. Apply lightly; usually the reflections are fairly subtle. If you feel that the sun would be hitting the eye, then add a bright highlight dot using white and a touch of Yellow Ochre. Be sure not to make it too big or overpowering.

Last, add a lighter area on the iris opposite the lightest part of your highlight. As light passes through the eye, it creates this lighter area.

Noses

Wild canids have an incredible sense of smell. The nose is designed to facilitate taking in all those intriguing aromas. It is moist, relatively large and has slits on the sides to help the nostrils expand as the animal inhales. Nostrils basically form a comma shape.

Wild canids' noses are always various shades of black, unlike cats, whose noses can vary from pink to black. Canid noses are not smooth and hard, but have a bumpy texture, particularly on the top, and are very flexible, not hard and rigid.

There is always a little indentation where the nasal bones come up the top from the nose itself. This is more obvious in certain types of light. The bottom of the nose forms a small V that forms the area where the lips come together.

All dogs' noses are basically the same. Get close to study and sketch your (or a neighbor's) dog's nose so that you can better understand the structure of the nose.

STEP 1: *Draw the Nose*

Noses can throw off the proportions of the face if they are drawn incorrectly. Be sure to use a good reference (even your own dog's nose will do). Lightly sketch the nose.

STEP 2: *Lay In the Underpainting*

Mix a base color of Burnt Umber, Payne's Gray, Ultramarine Blue, a touch of Magenta Deep and a touch of white. Paint the nose, leaving a little of your drawing showing as white, if necessary, to be able to see the structure. Paint the nostrils with Payne's Gray (Remember: Never use black). Pay attention to the nostrils, which are shaped like commas.

Step 3: *Refine the Nose*

Mix some white and a touch of Hooker's Green into the underpainting mixture you used in step two. Paint this onto the lighter area of the nose. Observe your reference carefully. Generally the front part of the nose is smoother and more reflective, so make it a little lighter in color. Use some of this lighter mixture to dab onto the area of the nose where light will hit it. Remember, canids' noses are textured, not smooth. Then, using Payne's Gray, paint the darker areas of the nose, adding some shadow areas around the highlighted bumps you created.

Step 4: *Create Highlights*

In my painting I decided that the nose was a little too blue, so I added a Burnt Umber wash on it. Remember how I told you in chapter one that layering with washes in acrylics can alter and enhance your work? This is a simple way to correct a minor problem. Now take some white and start working in some highlights along the bumpy texture of the nose and the nostrils. Since this nose is pointing down, there is some reflected light bouncing from the ground back up to the nose. Don't make your highlights too bright if the overall light of your painting is subdued. When beginning work on the muzzle above the nose, watch for the slight indentation that the nasal bones create.

Fur

It seems that there are as many ways to paint fur as there are artists painting it. There is no one way to do it. I spent years experimenting on my own until I developed my current technique after attending a workshop with Carl Brenders.

Brenders draws the hair coats of his animals first in a sepia-colored paint. Next, he airbrushes a basic background color over this underdrawing. He then reworks the hair coat in gouache on top of this. Since I don't use an airbrush, I experimented with some different approaches to painting fur that would produce the same basic effect. The following demonstration shows the technique I developed.

The most important thing to remember when painting thick fur, such as found on wild canids, is that there is not only hair but also air down in its depths. There are usually several layers of different types of hair. You want to create a painting that makes you feel like you can put your fingers into the fur, that the fur is not flat.

Watch for how fur rounds and breaks over muscles. It tends to clump into little V's at the point where it breaks. Look for shadows, creases and parts. Look carefully at your reference and really observe. Don't allow yourself to get on autopilot and mindlessly paint strokes to represent hair. It won't look realistic. Remember that wild canids live tough lives. Their fur is not smooth and consistent. Painting it that way will make your subjects look like they've just been to a dog-grooming parlor.

MATERIALS

Two no. 12 round brushes: one somewhat frayed, the other pointed
Gesso for white

Colors
Burnt Umber
Payne's Gray
Unbleached
 Titanium White

STEP 1: *Lay In Ground Color*

Mix Burnt Umber with some Payne's Gray. Using a somewhat frayed round brush, paint the hair texture. Cover the surface with fairly solid color, but also follow the direction of the hair. This will begin to create the effect of depth in the fur.

Step 2: *Detail the Hair*

Using Unbleached Titanium White (white and Yellow Ochre can also be used), begin detailing the hair. Use a drybrush technique with not too much water. Spread out the brush hairs with your fingers. Gently stroke the paint in the direction of hair growth. (Don't press hard or you will put down too much paint.) Pay attention to long and short hairs as well as to the direction the fur is growing. Form the hair into V clumps. This looks more realistic than painting individual hairs all spread out.

Step 3: *Add Color Wash*

To add depth to the fur, lay down a thin wash. On almost all animals, including this demo, I use Burnt Umber. For a red fox I will use a mixture of Burnt Umber and Burnt Sienna. Look for what watercolorists call "local color," or the main underlying color of your subject. Be sure to lay down the wash in the direction of fur growth.

Step 4: *Continue to Refine and Define*

Using combinations of white gesso and Unbleached Titanium White, detail the hair more. Use a more pointed brush, but resist painting every single hair. Remember hair tracts, bunched hair, and short and long hair. Then, with Payne's Gray, add black tips to the hairs, again making bunches. Also look for the shadows created where longer hair overlaps shorter hair.

These are the basics for rendering fur. If I were working on a real painting, I would repeat steps three and four until I was satisfied the fur had depth. I would begin adding washes of Yellow Ochre and/or Burnt Sienna, and sometimes even Ultramarine Blue, to specific areas where my reference suggested these colors might be.

Paws

Many times artists opt to hide the paws of their subjects in grass or behind other subjects. That's fine if it fits into your composition, but it looks very obvious and contrived when a clump of grass or a rock suddenly pops out of nowhere in an attempt to hide a paw.

Paws aren't difficult to paint if you take the time to understand their structure. Refer to the skeleton drawing on page 24. Notice how the toe bones are raised. The fur will break on these knuckles, and this will help to add a three-dimensional, realistic look to the toes.

When the weight is on the foot, the toes spread somewhat, so look for the spaces and shadows. Remember that there are four toes on the back foot and four toes touching the ground in the front. The front has a fifth toe—the dewclaw—partway up the leg. The nails will be blunt except for the dewclaw, which is sharp.

MATERIALS

Pencil
No. 10 round brush
White gesso

Colors
Burnt Umber
Payne's Gray
Unbleached
 Titanium White
Yellow Ochre

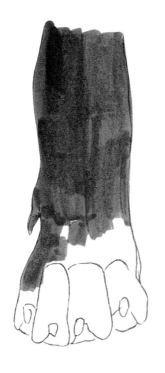

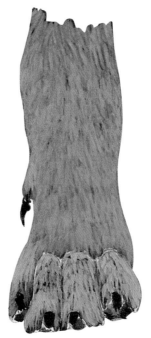

STEP 1: *Draw the Paw and Lay In Basic Ground Color*

Draw the paw, paying attention to your reference. You can observe your own dog's paws for details, but be aware that many breeds' toes are different from wolves. For example, retrievers tend to have flatter toes, while a greyhound will have higher toes. The paw is created in basically the same manner as the fur in the previous demo. Begin with a basic ground color of Burnt Umber mixed with Payne's Gray. Be sure you can still see your drawing by leaving a little white space if necessary.

STEP 2: *Detail the Hair and Paw Shape*

Proceeding the same way you did in the fur demo, begin laying in the fur with Unbleached Titanium White. For shorter hair, like on this leg, use more water in the mixture and scumble the texture of the short fur down the leg. For the toes, reduce the water a little so the paint is thicker. Draw hairs breaking over and down the toes. Let some of the brownish black underpainting show through as shadows and spaces behind and under the hair. Paint the toenails with Payne's Gray. Leave the pads and the undersides of the toes the brown-black of the underpainting. They usually show a little under the nails as well.

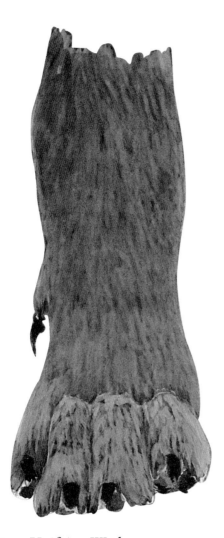

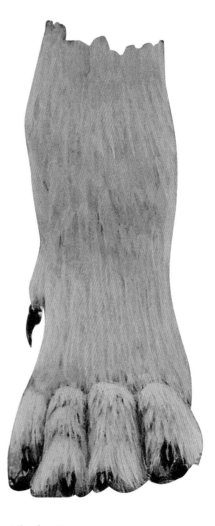

STEP 3: *Do a Unifying Wash*

When the previous step is dry, add a wash of Burnt Umber over the entire area.

STEP 4: *Finish the Paw*

Detail the hair more, using white gesso and gesso mixed with Yellow Ochre. Remember not to cover all the brown-black showing through the spaces of the hair where it is breaking over and down the knuckles and toes. Also, leave some of the ground color between the toes, particularly if the weight is on the foot. You can then add a touch of neutral gray—Payne's Gray mixed with white—along the tops of the nails as reflections. Don't make them too white. These aren't polished nails!

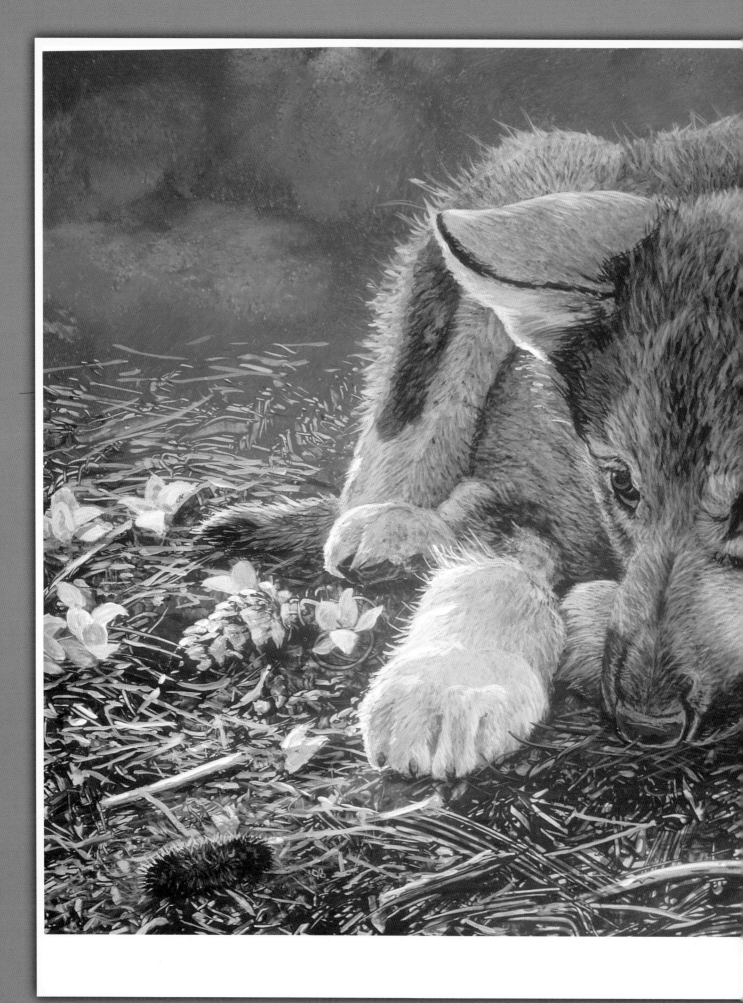

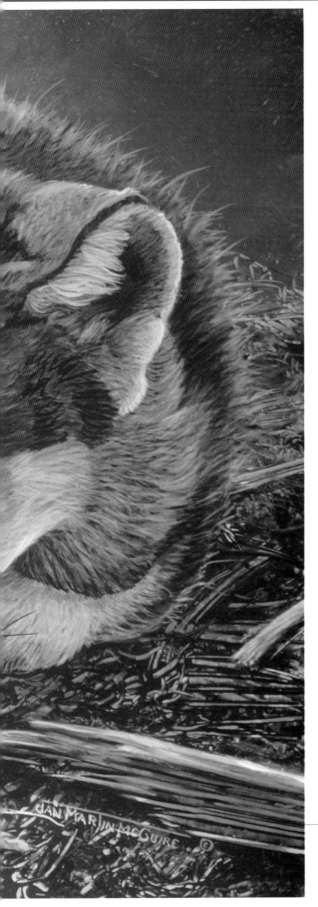

PUPS

It is difficult not to want to paint wild canid puppies. But there are a few basics you must know to do them well. First, they are not miniature versions of their parents. You can't take an adult wolf, simply scale it down and put it next to a full-grown wolf; it won't look like a puppy. In fact, it is really very startling to look at when an artist does this. Think of it in human terms: Human infants and toddlers are extremely different from adults. If you created a painting of a human infant but rendered the baby as just a scaled-down adult, think how weird and unnatural that would look!

Puppies have some common characteristics. Their heads and paws are always disproportionately large. In older pups, ears tend to be oversized as well. Pups tend to have a very round-eyed expression that gives them an innocent look. Their tails are pointed and covered with short, thin hair, and their bellies are pudgy. Their muscles are not well developed, and their joints tend to have a swollen look. When they are born, their eyes are blue—all mammals' are—and their coats are dark in color and very fuzzy. Their eyes and coats change to adult colors at about six weeks of age. Pups stay in the den until about three to four weeks of age. They leave the den permanently at about eight to ten weeks of age. All wild canids are born between March and May. By autumn, they are the size of adults.

The Intruder
Acrylic on Masonite
8" × 10" (20cm × 25cm)
Collection of Dr. Bob Beard

Reference Photos: Pups

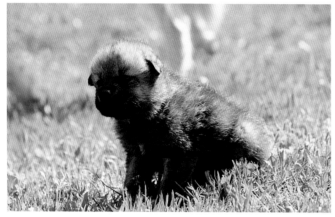

This is a three-week-old wolf pup. At this age the pups still spend most of their time in the den, but come out for occasional outings with mom. Note the folded-over ears.

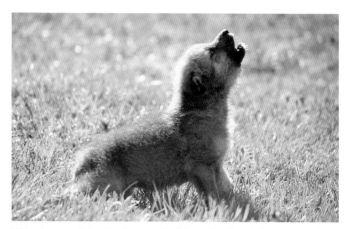

This photograph is of a three-week-old pup howling. This seems to be an instinctive behavior exhibited at a very early age.

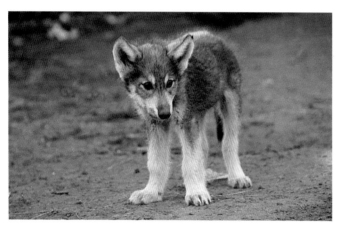

By the time wolf pups are twelve weeks old, they stay out of the den for good. Notice the oversized feet and ears and the "puppy" (round) belly.

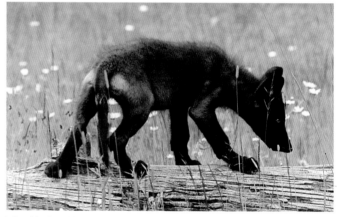

This black wolf pup is about twelve weeks old. He is very gangly and awkward at this age. Notice how thin the tail is.

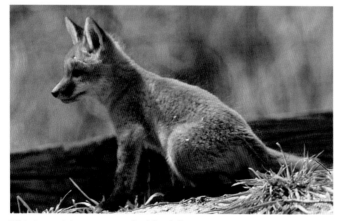

This is an eight- to ten-week-old red fox pup. Notice the large head and the fuzzy fur.

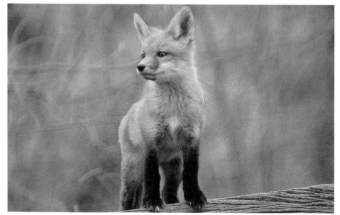

This eight- to ten-week-old fox pup shows the typical wide-eyed look of pups.

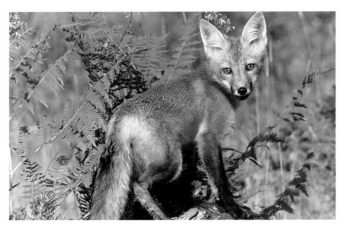

This red fox is about three months of age. It is beginning to look more like an adult but still has the wide-eyed juvenile look.

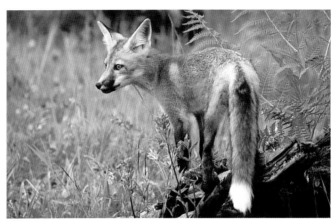

This three-month-old fox's tail is beginning to fill out, but it is still on the thin side.

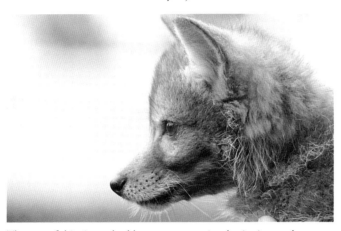

The eyes of this six-week-old coyote pup are just beginning to change from blue to gold. Even at this age, the rounded forehead and pointed muzzle that are characteristic of coyotes are clearly evident.

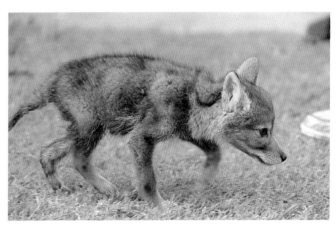

This is the same six-week-old pup. Notice the wooly look of the baby fur as well as the thin, tiny tail. Also note how large the head is in proportion to the rest of the body.

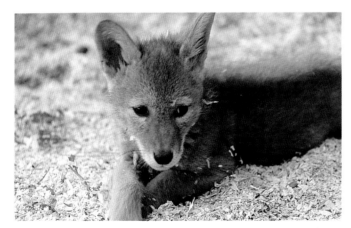

A seven- to eight-week-old coyote pup strikes a cute pose, showing her oversized ears and big baby paws. The white muzzle is obvious even at this age.

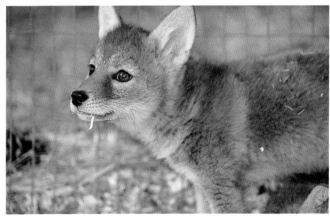

This photograph shows the seven- to eight-week-old brother of the pup in the previous picture. His attitude was very "alpha"—growling and nipping—while hers was more passive. By this age personalities are firmly in place. Notice that his eyes are now their adult golden color.

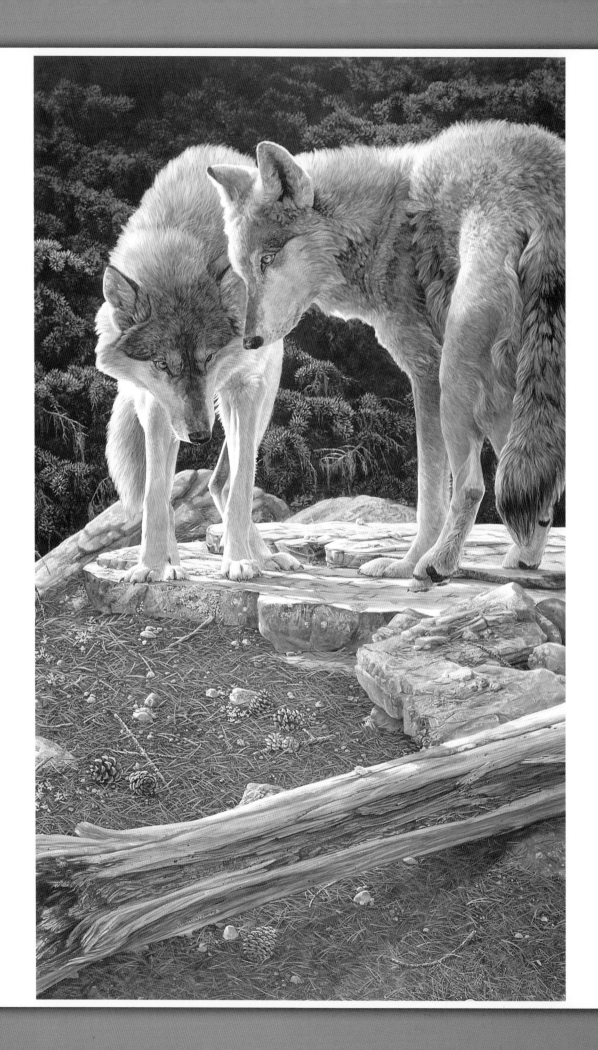

ATTITUDE, BEHAVIOR *and* MOVEMENT

All canids—including your pet dog—have a social system that is based on communication through body language and facial expressions. This is less true of foxes, which tend to be somewhat solitary, but it is still exhibited by them. It is particularly important in pack animals such as wolves. Conflicts can be resolved with ritualized movements, attitudes and behavior. True fighting, where a member of the pack is actually injured, is very rare because each member knows and understands its position within the hierarchy of the pack.

For this chapter, I simplified a complex set of behaviors to include only the very basic ones that apply the most to artistic needs. However, as stated before, I highly encourage you to learn as much as you can about your subjects. I have recommended several books in the appendix that will further your understanding of the wonderful communication systems of wild canids.

Courtship
Acrylic and Chromacolour on Masonite
48" × 24" (122cm × 61cm)
Collection of Mr. and Mrs. Bob Mogren

Social and Family Structures of Wild Canids

Wolves

Wolf pack size is variable. Generally there are six to twelve animals, but numbers as large as thirty have been reported. The purpose of the pack is threefold: to guarantee the survival of the pups; to defend territories; and to engage in cooperative hunting of large prey. Communication within the pack is based mostly on visual cues. Pack structure is set up on the pecking order system. The three basic positions within a pack are referred to as alpha, beta and omega. Usually an individual's status is determined early in puppyhood.

Alphas: Alpha is the top position. There are two alphas: a mated male and female. These animals are the ones that breed and are the decision-makers within the pack. The rest of the pack helps raise the pups, ensuring the survival of the litter. The alpha's posture is one of overall confidence and dominance.

Betas: Betas are in the middle, but pecking orders are well defined within their ranks as well. They must know who is over and who is under them and act accordingly. Dominant behavior is exhibited with lower-ranking animals, the same as is displayed by alphas, but submissive behavior must be adopted around alphas or higher-ranking betas.

Omegas: There is only one Omega, and he is at the bottom of the heap. He is in a constant state of submission and apology to all other members of the pack. Generally he stays on the outskirts of the pack as well, not being allowed to intermingle or feed until the rest of the pack is done.

Coyotes

Coyotes have a more loosely defined system. While pairs do mate for life, pack structure varies greatly. Eastern coyotes seem to not form packs at all in many cases. Western coyotes are known to have packs of three to eight individuals. The positions are the same as those of wolves, although there doesn't seem to be a well-defined omega position. The betas are almost always the previous offspring of the alpha pair. The purpose of the coyote pack is to defend territory and raise pups. Hunting is generally done on an individual basis, although pairs have been known to work cooperatively in flushing out and catching prey such as mice.

Foxes

Foxes are solitary, although they do tend to mate for life. The father's role in raising pups is under much debate. Many observers feel he doesn't have anything to do with the female once mating occurs. Others, myself included, think he takes a more active role, at least bringing food to the female in the den. Perhaps they are as individual as humans are—some are good mates and fathers, others are just plain deadbeats! Showing more than two foxes in a painting—unless you are depicting a mother and pups—would not be accurate.

On the following pages, I have done some drawings to help illustrate basic facial expressions, body language and other behaviors shown in wild canids. Remember that these are very simple and basic. As with humans, several expressions may be combined when an animal is feeling conflicting emotions.

Facial Expressions

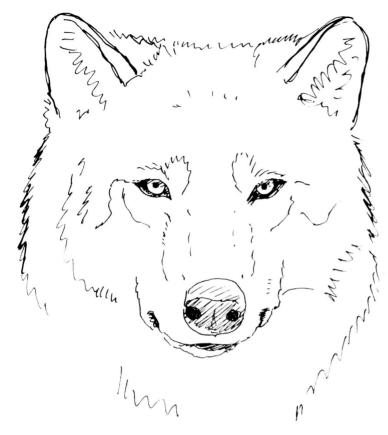

Normal—Relaxed

Normal relaxed eyes are not open wide and are not pulled back into slits. Relaxed ears may be either forward or back, but not pinned back or pulled strongly forward. The lips are loose. This expression occurs during restful times with no strong social interaction.

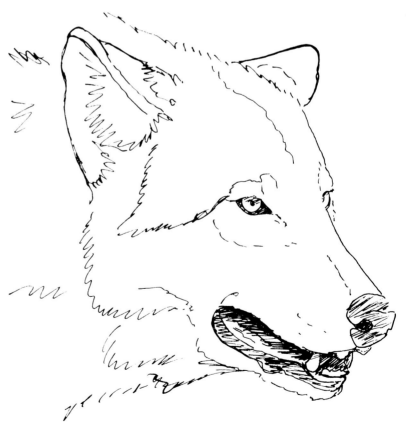

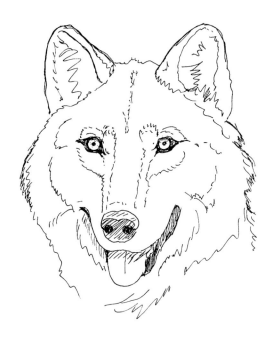

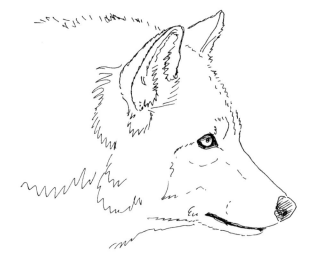

Normal—Alert
The eyes are alert and widened. The ears are pulled tightly forward, forehead creased. The lips are tight. Often the nose is raised to try to catch a scent. This expression is seen on the faces of alpha wolves when they are disciplining a member of the pack (the "stare down"). It is also seen in all members of the pack when hunting or when something of interest captures their attention.

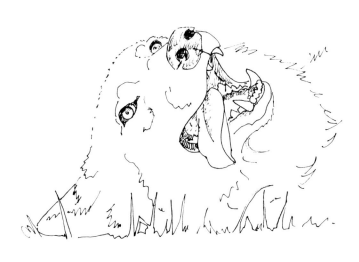

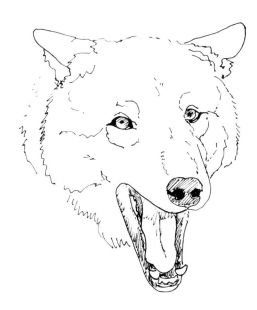

Happy/Playful
Obviously "smiling." The lips are pulled up and back (but not stiff and tight). The mouth is often open, with tongue lolling. The ears are either forward or back, but they are always in a relaxed position. The eyes are relaxed as well.

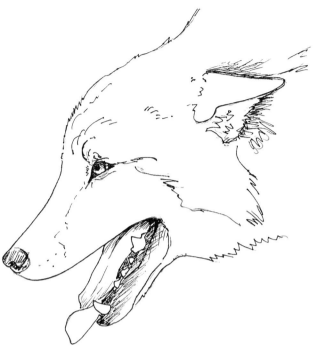

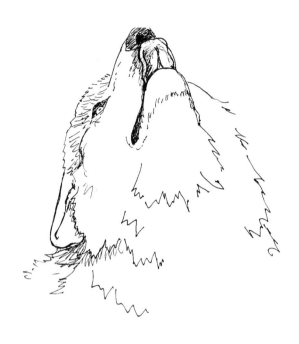

Submission/Apologetic

The eyes are slitlike. The lips are pulled back tightly in a grimace, sometimes with teeth showing. (With other submissive body language accompanying it, this is not interpreted as aggressive.) The tongue frequently flicks in and out. When actual contact is made, the submissive wolf will often lick the muzzle of the higher-ranking wolf. The hair on the forehead, neck and hackles is flattened as much as possible. The ears are pinned back tightly against the neck. This expression is used with appropriate body language when approaching any wolf higher in rank.

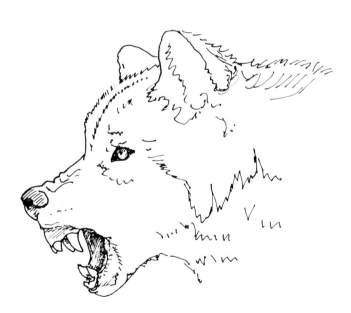

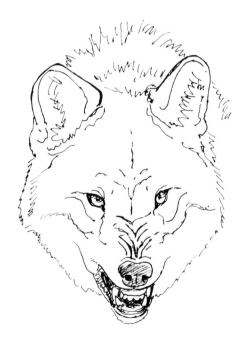

Aggression

The eyes are widened, but generally distorted because of the snarling face; the corners tend to pull up in back. The ears are generally forward. The lips are tight and pulled forward (not back into a grimace). The forehead, neck hair and hackles are raised to make the animal appear more formidable. A dominant wolf exhibits this behavior when a subordinate wolf pushes his limits.

Body Language

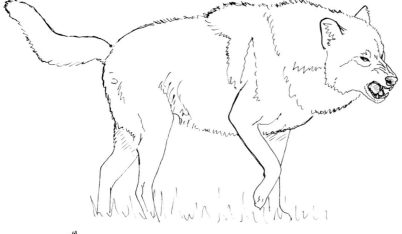

Extreme Aggression

In addition to the facial expressions already noted, the wolf raises the guard hairs on all parts of the body to look more formidable. There is an exaggerated stiff-legged gait and the tail is held higher than the back, generally at a crooked angle.

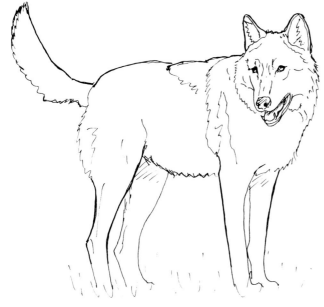

Dominant

This is the general attitude of an alpha wolf: confident and relaxed, but alert. The tail is held level with or higher than the back.

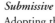

Submissive

Adopting the submissive facial expressions already noted, the submissive wolf who is being approached by a higher-ranking individual crouches slightly, which gives it a somewhat arched-back look. Generally the head is lowered and sometimes turned up at an angle. The tail is always low and tucked between the legs to some degree. Many times, a submissive animal will raise a paw slightly as well.

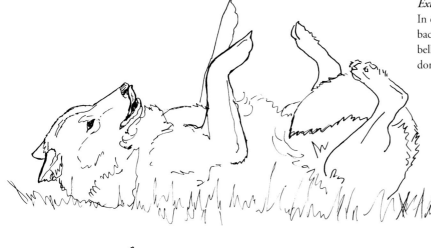

Extreme Submission

In extreme situations the submissive wolf will fall onto its back, tightly pulling the tail between its legs up against the belly. It purposely exposes the groin and throat area to the dominant wolf.

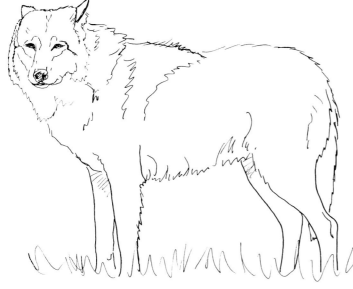

Normal—Relaxed

This wolf is not interacting in any social situation. Its ears and eyes are relaxed and the tail is hanging neutrally.

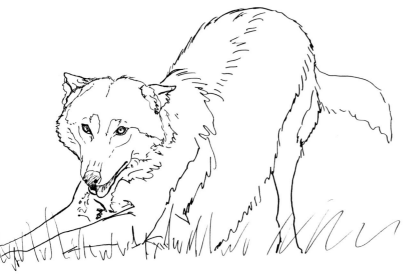

Happy/Playful

This posture is easily identifiable to any dog owner. It is an invitation to play. The tail is wagging and the muscles are tense, but only because the animal is ready to bound away to begin a game of tag. Other postures include rolling on the back, which is similar to the submissive posture, except that the tail is not tucked tightly to the belly and the ears aren't pinned back tightly.

Vocal Communication

Wild canids communicate vocally as well as with body language, but to a lesser degree. They whine, snarl, growl, yip and bark, but the prolonged barking of our domestic dog is not heard in wild canids. The most widely recognized form of communication—and the most romanticized—is the howl exhibited by wolves and coyotes. Howling may occur at any time of day, although it seems to be most frequent (particularly in coyotes) at dusk. Howling allows animals to communicate over long distances as well as to gather other pack members together. It acts as a rallying cry before a hunt, and sometimes seems to be done for pure pleasure. Generally much excitement, tail wagging and licking precedes howling. Once one animal begins, the rest of the pack seems to feel an almost overwhelming urge to join in. This is why paintings that show only one wolf in a pack howling are unnatural. Sure, there are moments when one animal winds down before it catches its breath and begins again, but generally when one is howling, everyone is.

Wolves' howls begin low and are drawn out, undulating as the muzzle is pointed upward and forward. They tend to move little while howling, seeming to concentrate all their attention on the music of their howl. However, they may howl while lying down or sitting as well as while standing. My observations are that wolves tend to howl with their mouths more closed and their lips pushed forward more than coyotes. Coyotes have a yipping howl, with their heads thrown up and back, mouths open wide. The coyote howl is accompanied by much exuberance. Many times animals actually dance from foot to foot or even leap into the air.

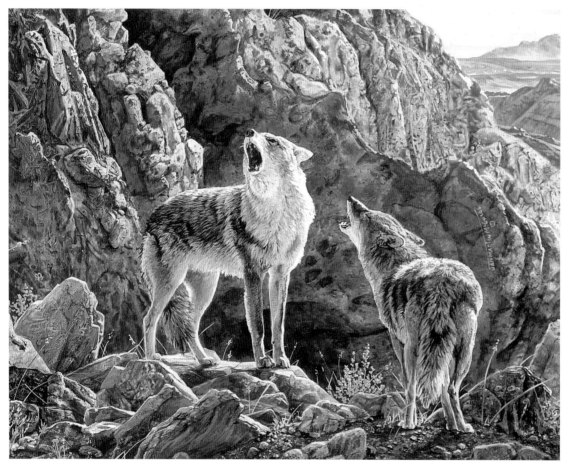

Vocal communication, including howling, is an important part of communication in wild canids. Howling allows members of the pack to communicate across vast distances, as these two coyotes are doing.

Evening Serenade—Coyotes
Acrylic on Masonite
8'' × 10'' (20cm × 25cm)
Private collection

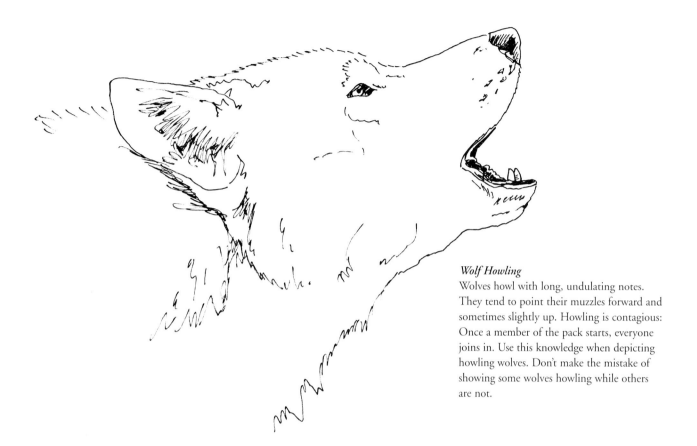

Wolf Howling
Wolves howl with long, undulating notes. They tend to point their muzzles forward and sometimes slightly up. Howling is contagious: Once a member of the pack starts, everyone joins in. Use this knowledge when depicting howling wolves. Don't make the mistake of showing some wolves howling while others are not.

Coyote Howling
Coyotes tend to get very excited when howling. They throw back their heads and even hop from foot to foot. Unlike wolves, coyotes make their quick, yipping howl with their mouths wide open.

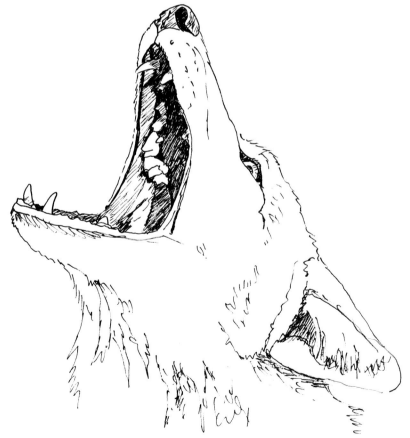

Movement

Canids have three basic movements: walk, trot and lope. The trot is used most, as it carries the animal over wide areas without expending a lot of energy. The lope is used to escape from danger or for chasing prey, and sometimes in play for short romps. Wolves trot at 5 mph and lope up to 30 or 40 mph. They can travel up to twenty miles daily in search of food. Most long-distance traveling is done in the evening or at night.

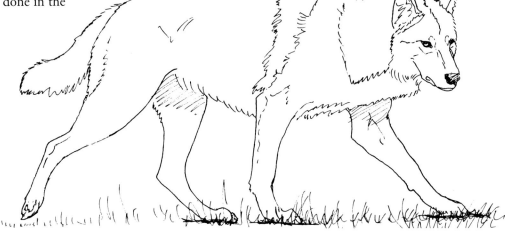

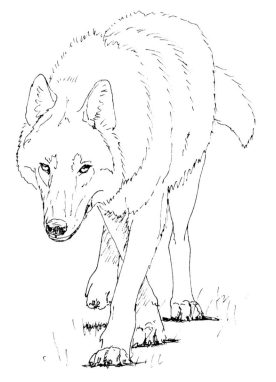

Walk
The walk is a general-purpose movement with a four-beat gait. Three feet are on the ground at all times; each foot touches the ground separately. Sequence: Left hind, left fore, right hind, right fore.

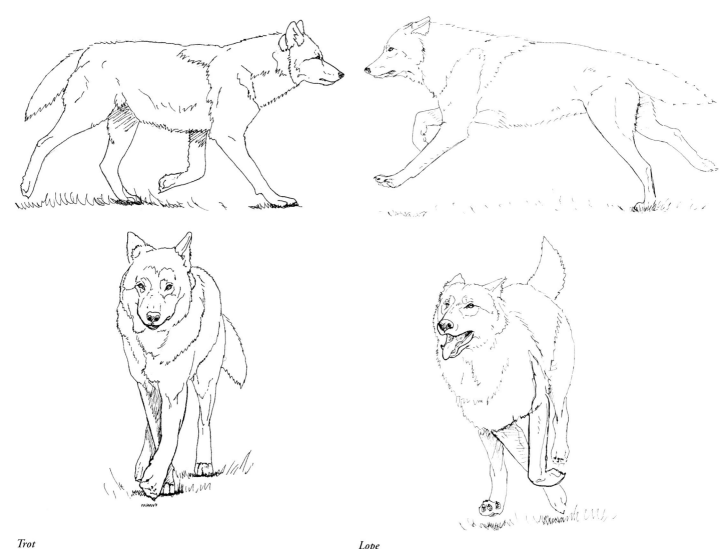

Trot

The trot is the most frequently used gait for traveling. It is a two-beat gait with the legs moving in alternate pairs. Sequence: Left hind at same time as right fore, then right hind at same time as left fore.

Lope

The lope is used for chasing prey, chasing intruders out of territory and sometimes in brief periods of play. It is a four-beat gait. Basically it is like a coiled spring: the legs curl under the body, then push off to create a leap and finally recoil. Sequence: Left hind, right hind, left fore, right fore and then a suspension before beginning again.

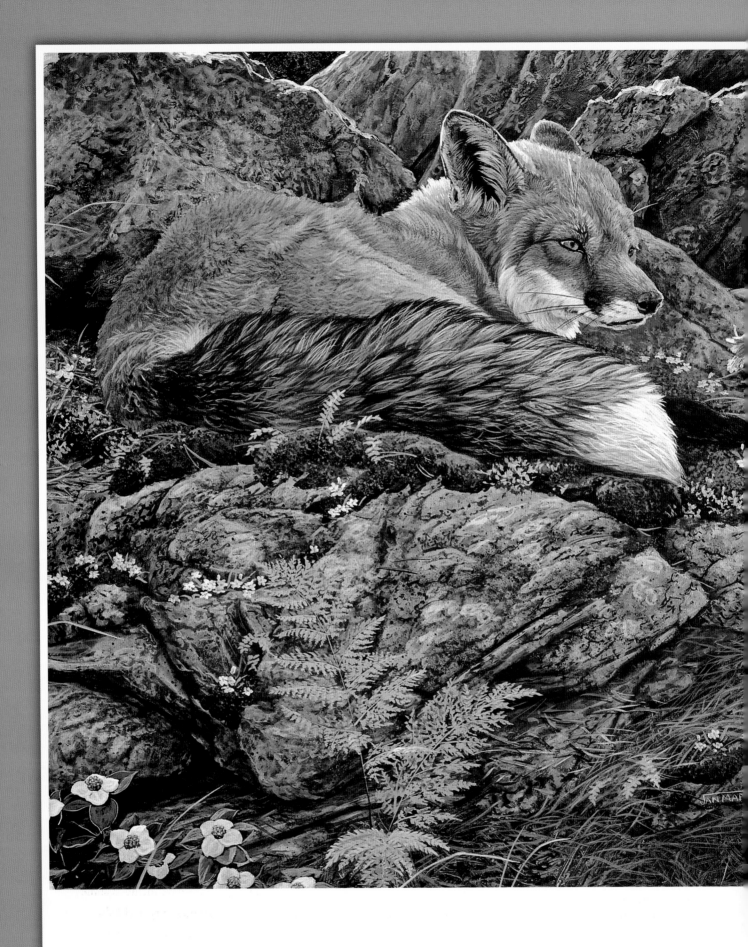

NATURAL HABITAT

Why am I covering habitat in a book you bought to learn how to paint wolves, foxes and coyotes? Because to create an intriguing, exciting painting of wildlife, the artist must include a sense of the animal's natural environment.

It is not always necessary to paint large vistas or an extensive habitat. Sometimes just creating a realistic rock for the animal to lie on establishes a sense of place, a sense of wilderness that gives the viewer the illusion of looking through a window into a natural setting. This is one of the fun things about being an artist: to create whole settings that add to the drama and interest of the painting you are creating. In this chapter, I will share some of my favorite tricks and techniques for creating realistic rocks, moss, bark, ground cover and grasses.

Research is extremely important in creating accurate environments

for your paintings. Traveling to the areas you want to paint is always best, but watching nature shows and reading lots of books will help. I am a big believer in books and have a large natural history library. However, even a few field guides in your studio will go a long way toward helping you paint as accurately as possible. One set of guides I find very useful is a series called *The Audubon Society Nature Guides.* These helpful guides list specific elements found within a given habitat, such as exact trees, flowers and grasses.

Do as much research as you can. There are always exceptions to rules, but it is best to paint wildlife in settings where the general public—those who will view and perhaps buy your work—expects to see a certain species. I have included some photo examples of typical habitats for wolves, foxes and coyotes.

Spring Beauties
Acrylic and Chromacolour on Masonite
16" × 20" (41cm × 51cm)
Collection of Susan and Eric Ruppert

Ranges of Wolves, Foxes and Coyotes

It is important to know and understand the habitat in which each animal is found. Ranges will tell you what type of habitat is correct for the animal you are depicting. For instance, after looking at the range maps, you know that showing a timber wolf in a swamp setting with alligators would be incorrect. The red wolf, a subspecies that we are not covering here, would be found in this type of habitat. Please note that these maps are only meant to give you a general idea of where the animals can be found. The boundaries are not exact.

Places where you have the best chance of seeing or hearing wolves in the wild

Denali National Park, Alaska
Algonquian Provincial Park, Ontario, Canada
Superior National Park, Ely, Minnesota
Yellowstone National Park, Wyoming

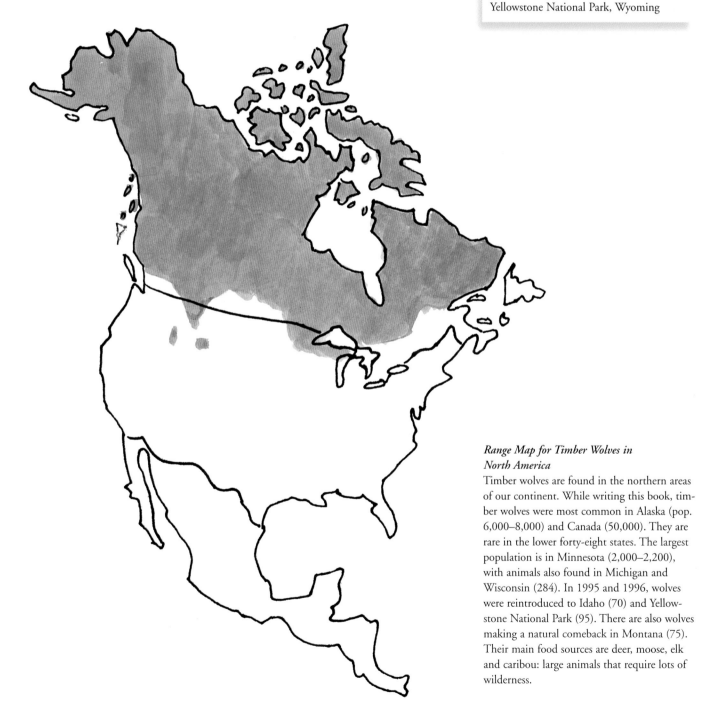

Range Map for Timber Wolves in North America

Timber wolves are found in the northern areas of our continent. While writing this book, timber wolves were most common in Alaska (pop. 6,000–8,000) and Canada (50,000). They are rare in the lower forty-eight states. The largest population is in Minnesota (2,000–2,200), with animals also found in Michigan and Wisconsin (284). In 1995 and 1996, wolves were reintroduced to Idaho (70) and Yellowstone National Park (95). There are also wolves making a natural comeback in Montana (75). Their main food sources are deer, moose, elk and caribou: large animals that require lots of wilderness.

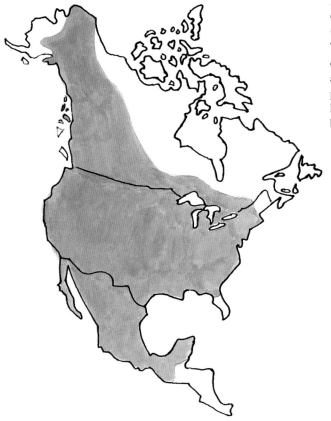

Range Map for Coyotes in North America

Coyotes are extremely adaptable and are expanding their range. Today they may be found in almost any type of habitat, from desert to city. This is because they are omnivores; that is, they eat almost anything that doesn't eat them first. They are highly intelligent and have learned to live around man. Because of their wide range, they have adapted in size and pelage (coat) to accommodate various surroundings. Coyotes found in hot climates typically are smaller and have much shorter coats than their brethren farther north.

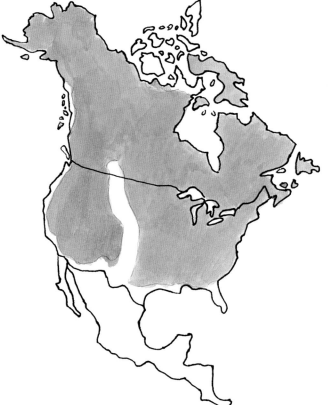

Range Map for Red Foxes in North America

Red foxes have a large range, adapting to a wide variety of habitats. They also are omnivorous, eating large amounts of berries and other vegetation as well as mice, rabbits, frogs, birds and other small prey. Even more than the coyote, the red fox has adapted to being close to humans, often hunting in suburbs and farmyards.

Typical Wolf Habitat

Wolves are found in isolated areas in the far north of our continent, generally far from civilization because they tend to be very shy and shun man. Think of a vast wilderness of pine and birch forests with mountains and streams when considering the right setting for your wolf painting.

Tundra area with spruce and willow trees—Denali National Park, Alaska

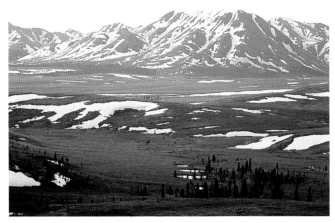

Open tundra area with Alaska Range mountains—Denali National Park, Alaska

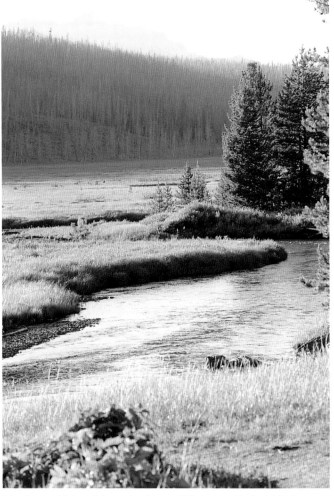

Meadow and bogs with nearby forest—Yellowstone National Park, Wyoming

Frozen snow-covered lakes, rocks and forest—Superior National Park, Ely, Minnesota

Typical Coyote Habitat

Coyotes can be safely painted in almost any setting, from mountain areas to city highways. However, many people still relate them and their mournful song to open prairie skies. Following are typical "wild" areas where coyotes are common.

Rocky desert area with sparse vegetation—Utah

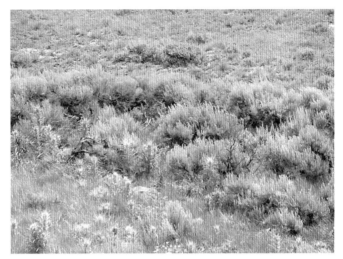

Sage meadow—Yellowstone National Park, Wyoming

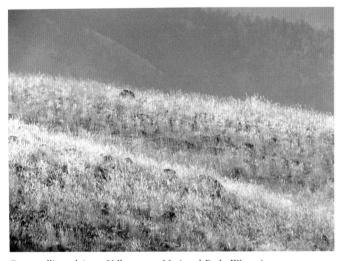

Open rolling plains—Yellowstone National Park, Wyoming

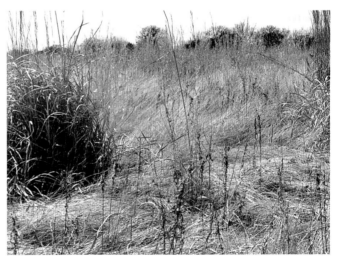

Grasslands—Tall Grass Prairie Preserve, Oklahoma

Typical Red Fox Habitat

Like coyotes, red foxes may be painted in almost any setting. They may safely be depicted around all sorts of human habitation, but especially around old barns where they hunt for mice. Foxes also tend to like edges, such as along roads or where forests meet meadows.

Abandoned stone barn—Ontario, Canada

Cropland—Kansas

Edge of hardwood stand with open meadow—Missouri

Small stream with grassy cover—Pennsylvania

Painting Habitat Elements

I am going to show you how to create the various details of the up-close habitats I use in my paintings. I am a big fan of trying to create the organic feel of the textures of nature, and I utilize everything I can to achieve a realistic look.

Nature is random and it's important to paint it that way. Unfortunately it is human nature to organize, thus we tend to let our brains tell us how to paint things such as pebbles or grass. When we allow this to happen, we end up creating paintings that look contrived. Random pebbles on a beach end up looking like biscuits that are all the same size and shape and all lying in exactly the same direction—like we'd see on a cobblestone walk. Or we paint grass with blades all conveniently curving exactly the same amount, in exactly the same direction.

To circumvent this tendency, you will learn how to create a random, natural, organic underpainting in the following mini-demonstrations. We will build on this underpainting to achieve natural, lifelike renderings of the details of nature. Always use good reference photos and sketches for each element of nature that you are painting. Never make up anything; it will not look realistic if you do. Don't trust your imagination; it just can't conceive of all the variations in nature. Everything is unique—each tree, rock, wolf, bird and insect—so paint them that way.

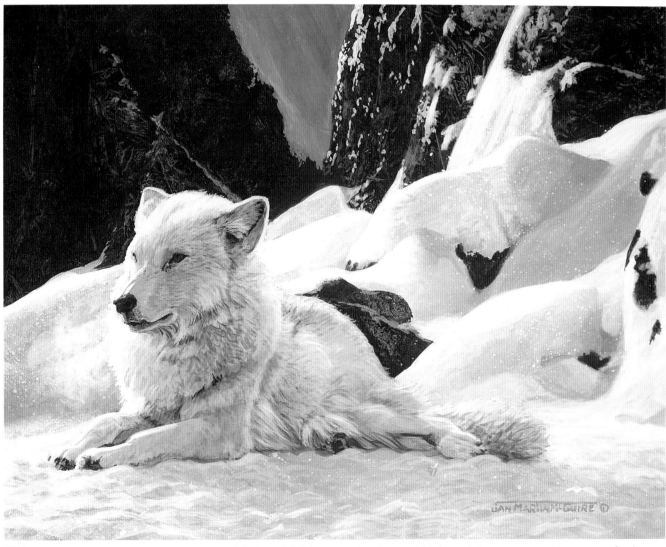

Whitescape
Acrylic on Masonite
8" × 10" (20cm × 25cm)
Private collection

Painting wildlife in a natural and accurate landscape is important to creating a sense of realism and a feeling of place and time.

Rocks

Rocks are some of the hardest things for an artist to tackle. Study rocks carefully; there are many different kinds. Think about what forces created them. Look for subtle colors and shadows.

MATERIALS

Cellophane
Round brush, any
 size from no. 8 to
 no. 12
Round brush, any
 size from no. 4 to
 no. 6
Gesso for white

Colors
Burnt Umber
Payne's Gray
Ultramarine Blue

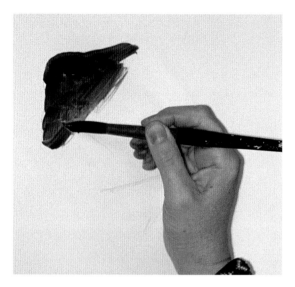

STEP 1: *Underpaint*

Lightly sketch in the shape of the rock. (Always use reference photos; never make it up.) Mix Burnt Umber with a small amount of Payne's Gray on your palette. Add water so it is fairly thin. Quickly lay the Burnt Umber and Payne's Gray mixture into your sketched area using a round brush size no. 8 to no. 12.

STEP 2: *Create Organic Texture*

While the paint is still wet, crinkle cellophane and lay it on the base color. Do the rock in sections according to the way the planes lie. Pay attention to the shape of the rock. You will have to experiment to find out how much crinkling works best for you.

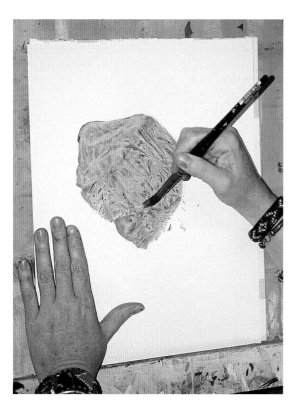

Step 3: *Add Dimension*

Once your rock is dry (you can speed drying time with a hair dryer), do a light wash of white gesso over the entire rock. Add dimension to your rock by adding more white highlights in areas of the rock that are facing the sun. This will give depth and realism to the rock and help prevent it from looking flat.

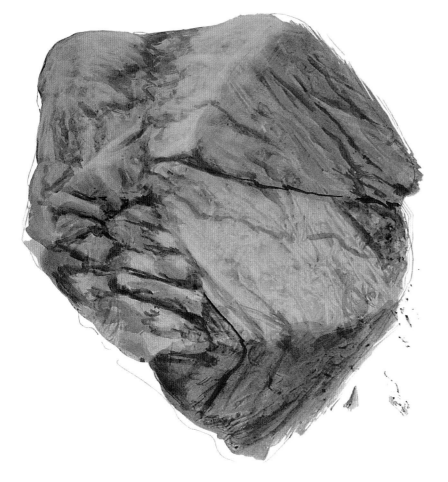

Step 4: *Add Shadows for Realism*

Go back into the rock and add some darks. Look at your reference photos, but also pay attention to the texture your cellophane has created. Look for areas that seem raised or indented and add light shadows in these places. Use your smaller pointed brush to paint where cracks might occur. Follow the contours of the rock. Keep working your rock until you feel it has a realistic look. Try not to overwork it, however, or you will destroy all of the natural organic look you've created with the cellophane. Lightly add some Ultramarine Blue into the shadows. This will help add some reflected color and light into your shadow areas.

Moss

There are many, many kinds of moss. Observe moss and take good reference photos. All types of moss can be done using this technique. For shorter, more velvety moss, use a sponge that has a smaller, more compact texture; for the longer, star-type moss, choose a piece of sponge that has a longer and looser texture. Always use a natural sea sponge. Synthetic sponges give an organized and unnatural look. Hint: Experiment with your natural sponges to add texture to rocks and also to create the look of lichens.

MATERIALS

Small piece of natural
 sea sponge
Round brush, any
 size from no. 8 to
 no. 12
Gesso for white

Colors
Burnt Umber
Cadmium Yellow
 Medium
Hooker's Green Hue
Payne's Gray
Yellow Ochre

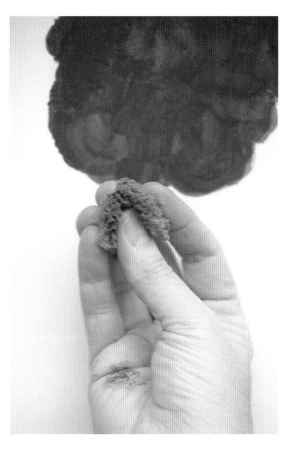

STEP 1: *Underpaint*

Using reference photos, lightly sketch in the general shape of the moss, paying attention to where the moss is, whether on a rounded rock or log or flat on the ground.

Mix Hooker's Green with a small amount of Payne's Gray on your palette. Paint in the general shape of the moss, using the tip of your brush on the edges to give a feathered look (moss is not hard edged). Select your piece of natural sponge. It should be thin and have texture along the edge. Moisten it slightly, then roll the sponge into an inverted U shape around your thumb.

STEP 2: *Use a Sponge to Create Texture*

When your background color is dry (you can speed drying with a hair dryer), mix Hooker's Green with a little Yellow Ochre and a small amount of white gesso on your palette. Don't make the mixture too light. You will be building up the look and texture of the moss, darkest area to lightest area.

Dip your sponge edge into your Hooker's Green and Yellow Ochre mixture. Don't overload it with paint, or you will lose the texture of the sponge. Paying attention to the shape of the humps on the moss, lightly dab your sponge onto the background color you have already painted. Don't cover the entire area; leave some dark areas.

STEP 3: *Add Highlights and Finish Details*

Add more Yellow Ochre to the mixture on your palette. Dab your sponge into this and then dab onto your painting. Don't totally cover what you've already done; just highlight the top for texture.

Using clean water, mix a little Cadmium Yellow Medium with a very small amount of Hooker's Green and a small amount of white gesso. Using a round brush of any size with a good point, add some finishing highlights. Push the tip of the brush gently away from you to add texture to the moss.

Add a little Burnt Umber to the undersides of the moss. Moss tends to turn brown close to the surface on which it sits.

Ground Cover

Ground cover can be anything that is lying on the forest floor under your wolf's, coyote's or fox's feet. It is usually debris that includes pine needles, sticks, bits of bark, pebbles and dead grass. Don't try to detail everything. You only have to give the impression of the detritus.

MATERIALS

Round brush, any size from no. 8 to no. 12
Funny Brush
Gesso for white

Colors
Burnt Umber
Payne's Gray
Yellow Ochre

STEP 1: *Create Organic Texture*

On your palette, mix Burnt Umber with a small amount of Payne's Gray. Add a little water so the mixture flows well. Using a large round brush, scumble the area where you want to create ground cover. While the paint is still wet, take the Funny Brush and rub, scumble and wiggle it all over the area to create a feeling of organic debris on the ground. This technique works best on very smooth, nonabsorbent supports, such as illustration board or Masonite. Keep working until the paint is dry, or it will run. Expand into what you've already done to create a blurred look.

STEP 2: *Refine Shadows*

Looking at reference photos and paying attention to what the shapes and textures you have created are telling you, lay in shadows with Payne's Gray under areas that appear to be raised. These elements will become pebbles, twigs, pieces of bark and pine needles. Work lightly at first, then gradually go darker. Pay attention to areas that overlap, such as one twig lying on top of another, creating a round shadow.

Step 3: *Add Highlights*

Using gesso, add some white highlights to the areas that are raised.

Step 4: *Create a Unified Look*

Add a wash of Burnt Umber mixed with a little Yellow Ochre. Keep repeating these steps until you achieve the finished look you are after, but don't overwork it.

Dirt and Pebbles

This demo will show you how to achieve the effect of realistic-looking earth under your subjects. It is relatively simple but very messy. Be sure to cover all your other work with newspapers secured with masking tape.

MATERIALS

Old toothbrush
Round brush, any
 size from no. 4 to
 no. 6
Round brush, any
 size from no. 8 to
 no. 12
Another big brush
 to strike against
 (no. 12 or larger
 works best)
Masking tape and
 newspapers
Gesso for white

Colors
Burnt Umber
Payne's Gray
Yellow Ochre

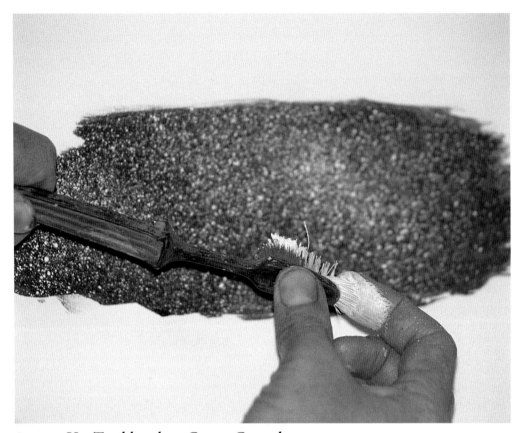

STEP 1: *Use Toothbrush to Create Granules*

Mix Payne's Gray with a small amount of Burnt Umber and scumble the area where you want to make the dirt. Don't make a solid dark patch. Remember to think organic texture at all stages. Using masking tape and newspaper, mask off all areas of your painting that you don't want to spatter. The spatters will fly onto your painting table and onto you, too, so cover up.

Using clean water, dip your toothbrush into some white gesso that has been thinned with water. You will have to experiment with how much water to use: too little and the paint won't spatter, too much and it will run. Holding your toothbrush so that it lies parallel to the area you want to spatter, lightly run your forefinger across the bristles while moving the toothbrush around. This will create a light overall spattering of small dirt or sand granules.

STEP 2: *Use Wash to Unify*

Making sure that what you've done is dry, apply a light wash of Burnt Umber over the entire area. Sometimes drying can take a while because the paint is built up on the raised granules. Using a hair dryer helps.

STEP 3: *Create Larger Pebbles*

Now create some large pebbles. Mix some white gesso with a little Yellow Ochre. Add water to create the desired consistency. The same experimentation applies as in the toothbrush technique. Load a no. 8 to no. 12 round brush with the mixture. Sharply rap the loaded brush across the handle of another large brush. This will cause large spatters to appear. If your drops are too thin they will run down your painting. Try working on a flat surface.

STEP 4: *Add Shadows and Highlights*

Make your pebbles more three-dimensional by adding shadows and highlights. Using the smaller brush, create shadows under the larger pebbles by adding Payne's Gray underneath them. Next, using white gesso, create whiter highlights on the tops of the pebbles.

Bark

This technique may be used for almost any type of bark simply by varying the way you crinkle and lay down your cellophane. Be sure to observe how the bark is lying on the trunk and manipulate the cellophane to follow those contours.

MATERIALS

Cellophane
Round brush, any
 size from no. 8 to
 no. 12
Round brush, any
 size from no. 4 to
 no. 6
Gesso for white

Colors
Burnt Sienna
Burnt Umber
Payne's Gray

STEP 1: *Underpaint*

Use a reference photo so you know what type of bark you are creating, such as pine, elm or oak. Mix Burnt Umber and Payne's Gray on your palette. Scumble paint onto your surface to begin creating texture. I wiped off edges of raised paint with my fingers as it was drying to create the white dots.

STEP 2: *Create Texture*

Now, doing the reverse of the technique done on page 72, lay down a layer of white gesso mixed with some water. Working quickly while it is still wet, crumple cellophane against the paint. Pay attention to the way the bark is lying on the tree. This demonstration shows a pine tree on which its bark tends to grow in vertical rows up and down the trunk.

STEP 3: *Apply a Unifying Wash*

When the layer of white is dry (use a hair dryer if needed), add a thin wash of Burnt Umber mixed with a little Burnt Sienna. Note: Burnt Sienna works well for the bark of a pine tree, but look closely at your reference photos. If you don't see any reddish highlights in the bark, just use a Burnt Umber wash.

STEP 4: *Add Details*

Now detail the bark. Look at your reference and note the texture your cellophane has created. Using a round brush (no. 4 to no. 6) with a good point, lay in dark areas, lines and shadows using Payne's Gray. Then gently and lightly highlight areas on the raised part of the bark using white gesso, paying attention to the roundness of the trunk and the direction the light is coming from.

Grass

Grass poses a big problem for many artists. The tendency is to paint every blade of grass individually, but the eye just doesn't see it that way. Think in terms of groups or clumps with just enough individual blades to give a realistic look. Look for blades that bend toward you, fall over and bend away. Look for dark areas under and behind the grass.

MATERIALS

Funny Brush
Round brush, any
 size from no. 8 to
 no. 12
Round brush, any
 size from no. 4 to
 no. 6
Gesso for white

Colors
Burnt Umber
Payne's Gray
Yellow Ochre

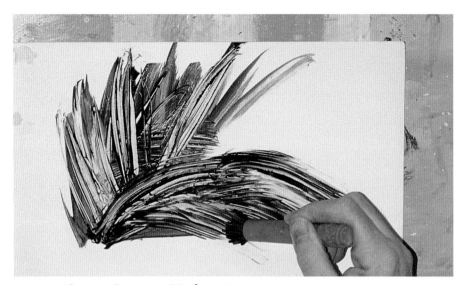

STEP 1: *Create Organic Underpainting*

Mix Burnt Umber with a very small amount of Payne's Gray on your palette. Brush onto your painting surface with a big round brush. While the paint is still wet, use the Funny Brush to add some texture to the paint, following the way the grass is growing. Remember, Funny Brush techniques work best on non-absorbent surfaces.

STEP 2: *Add Details*

Next, mix some white gesso and Yellow Ochre on your palette. Using a smaller brush with a good point, start detailing the grasses following the direction the grass grows. Cross over some blades; bend and break others. Don't be too consistent or organized. Remember, nature is random.

STEP 3: *Continue to Refine*

Add a wash of Burnt Umber and Yellow Ochre. Then, using Payne's Gray on a small brush, add dark areas in, around and behind some of the blades, primarily near the bottom of the growth area.

STEP 4: *Add Finishing Details*

Using your small brush, add more detailed grass blades. Don't follow what you've already done. You want to add depth and bulk to the grass. Repeat these steps until you are satisfied with the look. This technique may be used for green grass using mixtures of Hooker's Green and Yellow Ochre. Experiment to find what looks best.

Snow

The thing to remember when painting snow is that it is not white. On a cloudy day it is various shades of gray. On a sunny day it is various shades of blue and purple. Look for the texture of the snow as well as for the shapes. Snow is rarely flat. There are humps and bumps where the snow has covered rocks, vegetation and the contours of the ground.

MATERIALS

Old toothbrush
No. 10 old, frayed
 round brush
Gesso for white

Colors
Flesh Pink
Magenta Deep (or
 any warm violet)
Ultramarine Blue
Yellow Ochre

STEP 1: *Scumble in Underpainting*

Lay down the ground color. If it's a cloudy, overcast day the ground color will be a mixture of Ultramarine Blue and Payne's Gray. For this demo it's sunny, so the ground color is a mixture of Ultramarine Blue and Magenta Deep (just a tad). Use a rough brush and scumble in. Look for the shapes in the snow.

STEP 2: *Add Texture*

Using white, scumble in lighter texture over the top of the ground color. Make it stronger and heavier where the light will be hitting it.

STEP 3: *Create Highlights*

Using a mixture of white with a little Flesh Pink and Yellow Ochre, continue creating lighter areas of the snow.

STEP 4: *Add Final Details*

Put in the final touches by adding even more of the white-Yellow Ochre-Flesh Pink mixture to highlighted top areas. Then, using a toothbrush like you did for the dirt demo (page 78), spatter the same mixture onto the snow. It will show the most in the shadow areas. Remember to mask off any areas you don't want spattered. You should skip this step if you are depicting snow on a cloudy day, as there would be no obvious sparkles.

Research in the Field

As discussed in chapter two, research on the animal is important, as is researching habitats. I can't stress enough that your mind is like a computer: the more information you put into it, the more that will come out.

Feeling the wind in your hair as it blows over a mountain; touching the velvety texture of moss; smelling the earthy aromas of fallen, rotting logs—all this gets into your psyche and flows out the end of your brush as you create a true work of art. Simply sitting in your studio copying photos out of books will never give your work the heart and soul that all artists strive for.

While I depend a great deal on my camera—and advise wildlife and nature artists to do the same—working in sketchbooks and, whenever possible, painting in the field, is more important to train the hand, eye and mind. Another benefit of painting in the field is that it allows your eye to see three-dimensionally. Photographs flatten, distort and take the light out of shadows. If you paint while in the field, your eye will learn what is correct. You can then make compensations when you are back in the studio working from photos. Don't worry if the result is not frameable. You don't have to show anyone your sketchbook or field paintings. They are like the notes authors take—for your information only.

Equipment for Field Painting

It takes experimentation to find the right equipment for you, but after a little practice you will become hooked! This is what works for me.

Portable French easel
Small folding stool
Backpack to carry all supplies except easel
Sta-Wet Palette
Mist bottle to keep paint wet (and to cool off when it's hot!)
Bug spray
Sunscreen and hat
Collapsible water container with S hook to hang on easel
Bottle with a good seal for additional water
A couple of rags
Cottman watercolor set (for working in sketchbook)
Duct tape/masking tape
Assorted brushes, rolled in a bamboo place mat that has elastic woven in it to hold the brushes; include a toothbrush, Funny Brush, sponge and mechanical pencil
Plastic sealable bags with paint (the lids should be taped shut if traveling by plane)
Sketchbook
Field guide (you never know what neat birds you'll see while out painting!)
Several small, already-gessoed Masonite panels ranging in size from 5" × 7" (13cm × 18cm) to 9" × 12" (23cm × 30cm)
Cellophane

Equipment for Painting in the Field

Select a Location and Set Up

Select the area you want to paint in. It can be anything from a nearby park to distant mountains. Any time spent outside will help you grow as an artist. Many of the studio techniques that we used earlier may be used in the field as well, so don't forget to bring all the paraphernalia: toothbrush, sponge and so on. When setting up, pay attention to where the sun is. You don't want it directly over your shoulder. The glare on the painting surface will make it hard to distinguish colors properly. The sun may get very hot, so find a spot under a tree if you can. Just remember that the sun moves! A field painting is best done in a two- to three-hour time frame. After that, the sun will have changed too much and you will be fighting the changing shadows. Some artists go back at the same time several days in a row to keep working on a field painting so that they can have a more finished piece. I prefer to use field paintings simply as learning experiences and generally complete each painting in that two- to three-hour limit.

Pick a location to paint in the field—anything from a local park to a far-off mountaintop. Try to keep it simple and bring only what's necessary. Many artists find that painting on their lap is sufficient, but I like setting up a French easel and sitting on a small folding stool.

With the easel set up, the water bottle attached and the palette prepared, you're ready to paint.

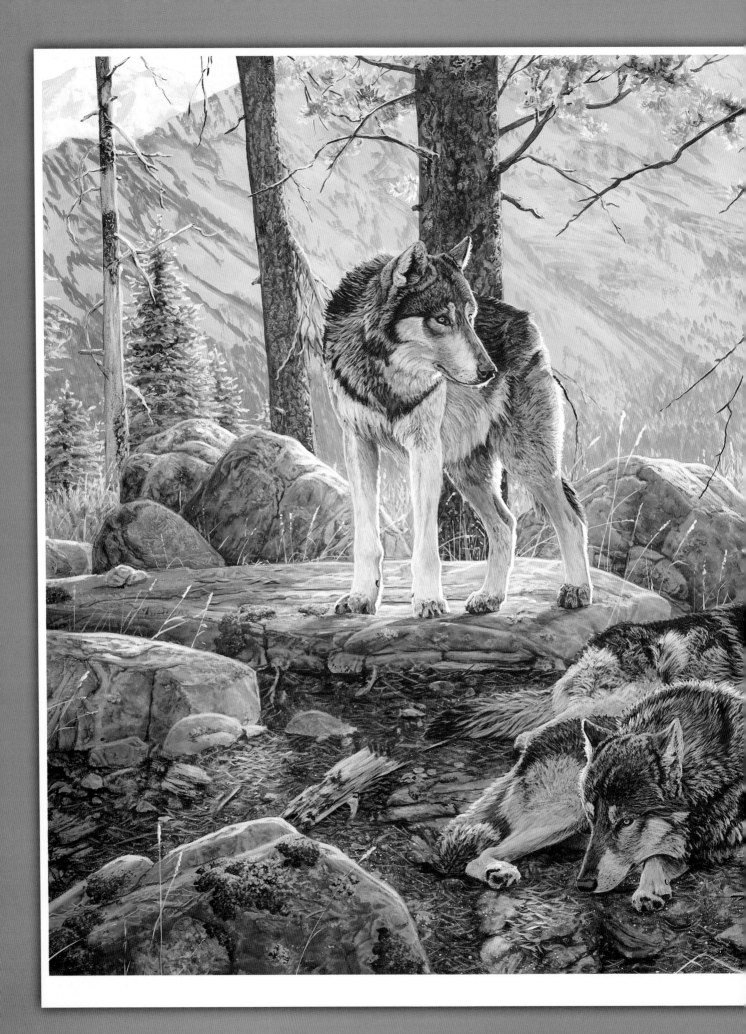

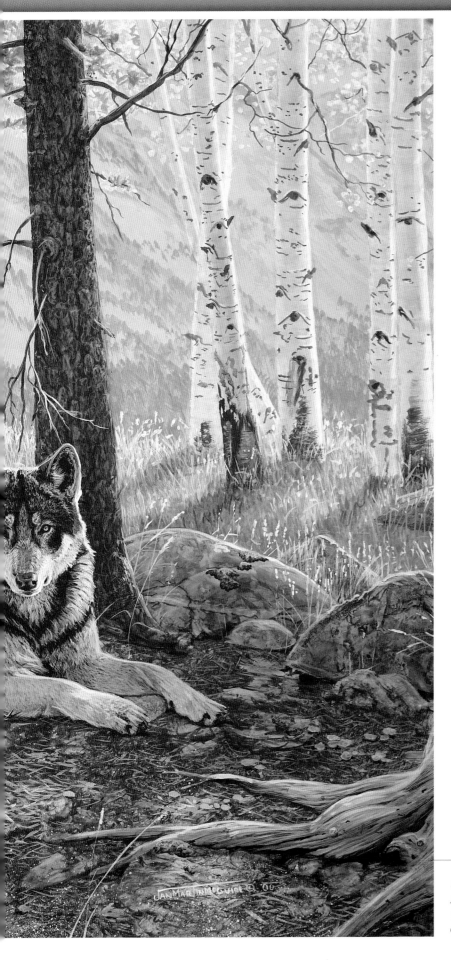

PAINTING
a Pack of
WOLVES

We are now going to do an actual painting, step by step, from start to finish. We will incorporate some of the mini-demonstration techniques from previous chapters as well as some new ones. The subject is a small pack of wolves resting in a mountain clearing, waiting for evening to fall to begin the night's hunt.

Snow in the High Country
Acrylic and Chromacolour on Masonite
18" × 24" (46cm × 61cm)
Collection of Pete and Marlene Luitwieler

Research

Research is the key to a good wildlife painting. It is necessary to understand your subject as thoroughly as you possibly can to paint it in a realistic and accurate manner. Reading about the animals and observing them firsthand, if possible, will help you make connections that will add life and soul to your painting. This will enable you to move the observer emotionally.

Where to Buy Reference Photos

Monty Sloan
Official Photographer of Wolf Park
(765) 567-2265
Denver Bryan
(406) 586-4106
Photoplus, Fred and Buffy Burris
(800) 525-3331
Keith Szafranski
(406) 222-0316 or (406) 222-3518

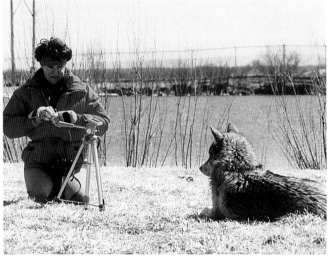

Research Idea: Sketching
Try to sketch as much as possible. Sketching helps implant the essence of the animal in your mind. Here I am using a very tiny sketchbook and pencil, because wolves are notorious for being curious and they will take every opportunity to steal items from you. I have taken my camera off the tripod so this wolf won't be tempted to grab the strap. While it is usually not possible to get permission to enter enclosures with wolves (for liability reasons), you can often get permission to sit close enough to make useful drawings.

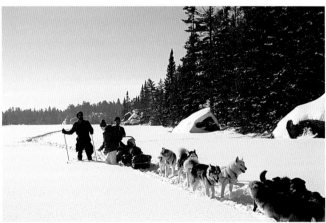

Work With Experts
Try to develop a network of experts that you can consult when you have questions. These can include professors, researchers, zookeepers or volunteers at refuges. Take advantage of classes, workshops and other events that will help you learn more about your subject and give you opportunities to work with experts. The International Wolf Center in Ely, Minnesota, offers several such programs. In this photo, I am with researchers from the center on what they call a "wolf weekend," dogsledding into remote areas of Superior National Forest and searching for radio-collared wolves. (That's me in the red parka.) Wolf Park in Indiana also offers several workshops. Both facilities are listed in the appendix.

Read, Study and Gather References
Use as many resources as you can when preparing to do your painting. Read as much as possible. Public and university libraries are good sources, but it's best if you can develop your own library. Used bookstores are good sources for nature books and magazines. Many Internet bookstore sites, as well as all major book chains, have books on nature. I have listed some of my favorite books in the appendix. To prepare for this painting I gathered my sketchbooks, many reference books and videos on wolves, and field guides on trees and plants. I also have photos, slides I purchased, magazine clippings and a large collection of animal hides, skulls and other bones.

Studio Setup

I am a proponent of creating a comfortable workspace that allows your creative juices to flow. It is very difficult to do your best work on a kitchen table, with poor lighting and many distractions, and where you must put everything away every night. If at all possible, find an area to set up a workspace for yourself: a spare bedroom, a corner of the basement or garage, or an outside space that you rent with other artists. You will be amazed at how a better working environment will help you achieve better results.

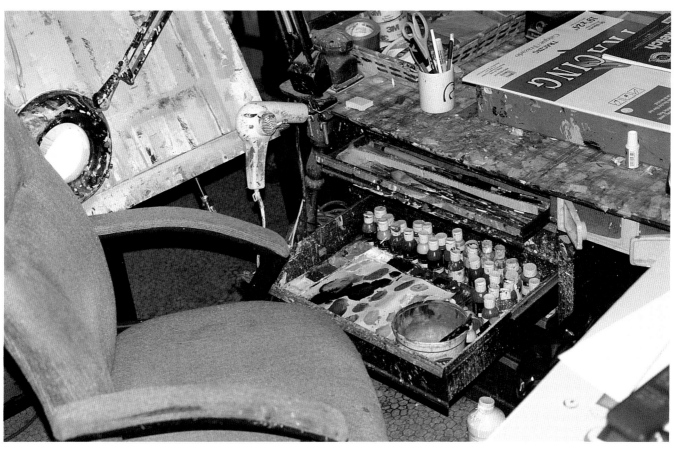

Studio Setup

This is my studio setup. Important elements include:

Lighting (not shown): An overhead fluorescent shop light hangs by chains from hooks in the ceiling to a height of about two feet over my painting area. It has a warm (pink) bulb and a cool (blue) bulb. I find this is a good color balance. These bulbs are easily purchased at any hardware or discount store. The pink ones are usually listed as "warm" kitchen or bath, or sometimes "sunlight" plant bulbs. Many artists insist on natural lighting, but I feel that since my work isn't going to be viewed outside, I don't see the need to make it look good only under natural light.

Easily adjustable drafting table: This Ensign EN48-3 drafting table's height and angle are adjustable with one handle, easily reached from my painting chair. It is 36" × 48" (91cm × 122cm). I absolutely love this table because with all the washes I do, I need something that converts easily from vertical to flat positions.

Magnifying lamp: This lamp is good for detail work, especially as the eyes get older. It is available from any office supply store.

Sears tool box under old rummage sale table: I have a Sears five-drawer Craftsman toolbox that sets under an old table I bought at a rummage sale for two dollars. The toolbox holds my brushes in the top drawer, miscellaneous items, such as tape, in the second drawer, and my palette, paints and water bowl in the third drawer. The other drawers contain materials such as extra paint, palette paper and cellophane. I use the table to hold my reference material while I'm working. My hair dryer is located here as well.

Ergonomic chair: A good comfortable chair that supports your back is a necessity if you spend any time sitting down while painting. This one is on rollers so I can push it out of the way when I stand to paint.

Multi-drawer office unit on wheels (not shown): Behind me is a three-drawer setup that holds my paint rags, sketchbooks and small Masonite panels. I found it at an office supply store.

Preparation

Buying and Cutting Your Masonite

After you have done your research and decided what size painting you want to do, prepare your Masonite. You can also buy perfectly good Masonite panels already gessoed, and I sometimes use these. If the surface is too slick, apply another coat or two of gesso.

I prefer to prepare my own Masonite. Buy several 4' × 8' sheets of untempered Masonite panels at a lumberyard or home improvement store. You can ask the store to cut sheets in half for you if you can't get them into your car, or ask the store to deliver them.

It is important to get untempered rather than tempered Masonite. Why?

Tempered Masonite has an oil added to the fibers, which are then compressed in a machine to make a harder board that is more resistant to moisture. That process makes water-based gesso slide off—maybe not right away, but eventually (I've had it happen). I generally buy the ⅛" (.3cm) thickness. Some artists prefer ¼" (.6cm) for larger paintings because the ⅛" (.3cm) can buckle. Because ¼" (.6cm) starts to get pretty heavy on a large piece, I use the ⅛" (.3cm) and gesso both sides, being sure to lay it flat to dry. This keeps the panel from buckling.

At home, I cut the Masonite to the size I need. The edges are always a little rough, so I sand them down with heavy grit sandpaper.

Gessoing and Sanding

Mix white gesso with Payne's Gray to create a neutral mid-tone gray. This gray will allow you to go up and down in value with a nice middle tone to start from. Paint several layers, sanding in between to create a very smooth surface. I feel that the texture of canvas or rough paper has nothing to do with the textures found in nature. The bumps and ridges are not only hard to work around when creating details, but in my opinion, they can be distracting to the viewer, as if to say, "Look, I'm a painting," rather than, "I'm a window to the natural world."

I like to prepare my own Masonite. I buy full sheets at lumber stores, then using a T-square and corner angle, measure the size I need. I cut it with a hand-held jigsaw. Always buy untempered Masonite for use with water-based paints. Tempered Masonite has an oil in it that will keep your water-based paints from adhering well.

You can tell if the Masonite is untempered if you can get your fingernail into the edge and peel back layers. If it's as hard as a rock, then it's tempered and not suitable for water-based paints and gessoes like acrylic.

Prepare your Masonite by painting on several thin coats of a neutral gray gesso. Mix Liquitex gesso with a little Payne's Gray (either acrylic or Chromacolour) until you achieve the value you want. I usually fill a large plastic container with a snap-on lid with this mixture to use over the course of several paintings.

Paint on two to three layers with a large soft brush, then sand with a fine sandpaper, such as 3M Silicon Carbide Superfine #400. Then paint several more layers, letting each dry between applications. I like a very slick surface. If you prefer a rougher surface, try applying the gesso with a roller.

Composing With Cutouts

Most artists use traditional thumbnail sketches to work out compositional ideas for their paintings (see chapter seven). In this case, however, I had already decided on the background and landscape. I liked the idea of a mountain peeking through trees, with cool tones in the background and warm tones in the foreground, but I was unsure how I wanted to depict the wolves. To help determine how many wolves and in what positions or attitudes they would be, I drew several wolves all to the same scale, then cut them out. I then drew a "stage setting" landscape on which I could move these cutouts around until I came up with the arrangement I liked the best.

Idea 1
I rejected this idea because, compositionally, it is more interesting to have an odd number of main elements.

Idea 2
I toyed with the idea of some sort of interaction between the wolves, but decided I didn't like the tension it created.

Idea 3
Actually, I made about ten of these cutout drawings, but this is the idea I ultimately decided to use. I like the relaxed feeling that this one projects, although it also suggests anticipation—a feeling of waiting for something to begin. The wolf who is standing, looking back into the scene, helps to lead the viewer's eye in a circular pattern around the painting.

Wolves in a Mountain Clearing

Drawing to Size

Creating a drawing to size helps work out the anatomy and placement beforehand. Attach the drawing to the top of your panel with masking tape hinges. This allows you to flip the drawing back and forth onto the painting so you can transfer elements as needed.

Transferring the Drawing and Masking

After transferring the drawing with Saral transfer paper, mask off the main elements with liquid masking fluid so that the underpainting of neutral gray gesso remains clean. I like to work from this neutral gray as a beginning building block for all elements. This technique keeps any distracting brushstrokes, or other marks that might be created when applying paint for the background, from showing up as bumps or ridges on your subjects.

Beginning to Paint

Start at the back of the painting and work forward. This helps to create depth. Don't put too much detail in distant objects. Your eye doesn't really see them and you will cause your painting to appear flat. As you work forward add more and more details, but try not to overwork. Try to give only the impression of detail. Robert Bateman is a wildlife artist who is a master at doing this. Get some of his books and study how he details only certain important elements, giving the impression that the whole painting is detailed. Textures help to give this illusion as well.

As I work on a painting, I cover my drafting board around the Masonite with all sorts of photos of wolves and habitat. This helps me get into a zone where I become totally right-brained and in tune with the painting. I want to feel like I am in that place, seeing those wolves. This is one reason I prefer to work on one painting at a time. It keeps my attention and interest focused.

TECHNIQUES

Used in Previous Mini-Demos

Rocks (pages 72-73)
Ground cover (pages 76-77)
Bark (pages 80-81)
Moss (pages 74-75)
Fur (pages 44-45)
Eyes (pages 39-41)
Noses (pages 42-43)
Paws (pages 46-47)

New Techniques

Distant landscape (atmospheric perspective)
Single grass blades
Single pine trees and a stand of aspens
Dead roots
Lichen

MATERIALS

18" × 24" (46cm × 61cm) untempered Masonite panel
Straightedges
Jigsaw
Fine sandpaper, such as 3M Silicon Carbide Superfine #400, and a hand sander
Neutral gray gesso (white gesso mixed with Payne's Gray)
Tracing paper, cut to 18" × 24" (46cm × 61cm)
Mechanical pencil
Masking tape
Masking fluid
White Saral transfer paper
Liquid hand soap (to protect brush when applying masking fluid)
Various sizes of round brushes
Large, soft flat 4-inch (102mm) brush, such as a Winsor & Newton gesso brush
No. 3 Winsor & Newton 240 Mop Brush
¾-inch (20mm) flat brush similar to a Loew-Cornell 7120 Rake
Cellophane
Funny Brush
Foam sponge (like what is found inside furniture cushions) cut to hand size
Toothbrush
Gesso for white

Colors

(Liquitex acrylics or Chromacolours. I used Chromacolors.)
Burnt Sienna
Burnt Umber
Cadmium Orange
Cadmium Yellow
Cerulean Blue
Hooker's Green Hue
Magenta Deep
Payne's Gray
Phthalo Blue (Note: Phthalo colors are stronger in Liquitex, so use sparingly.)
Phthalo Green
Ultramarine Blue
Unbleached Titanium White
Yellow Ochre

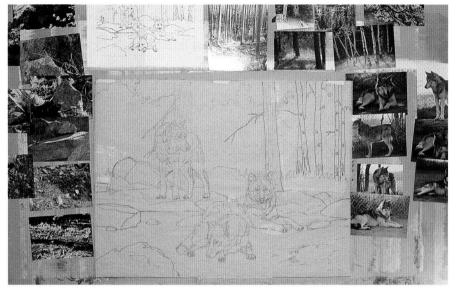

STEP 1: *Do a Map Drawing to Size*

After deciding which preliminary idea to use, do a drawing to size on a piece of tracing paper. Carefully work out the anatomy, including major hair tracts and markings. I usually do this drawing in pencil, but for this demonstration I used ink so it would reproduce clearly. Draw the main elements, keeping in mind that these may change or others may be added. This is the beauty of acrylic—you can change your mind as your painting progresses and you aren't stuck with everything you planned in advance.

Attach this drawing to the top of the Masonite panel with masking tape hinges. This photo shows the drawing attached to the gessoed gray Masonite along with the original cutout sketch I worked from. It also shows some of the reference materials I will be using, taped all around the painting.

STEP 2: *Transfer Drawing and Mask Main Elements*

Transfer the main elements of your drawing to the panel using transfer paper. Don't transfer details now—just draw around the main elements in a continuous outline. In this example, I've drawn the trees down to the standing wolf, around the rocks and reclining wolves, then back up and around the other trees. Next, cover this area to retain the pure gray background. You can use masking fluid to cover the whole area, but when covering a large area on a bigger painting like this, I prefer to cover most of it with cellophane and masking tape, saving the fluid for the edges.

Cover an old round brush that still has somewhat of a

point with liquid hand soap. This will keep the masking fluid from sticking to the hairs of the brush. Dip the brush into your masking fluid and paint along the edges of areas you wish to cover. Once the fluid starts to become sticky on your brush, wash the brush, reapply the liquid soap and masking fluid and start again. Two coats work best for thorough coverage. Be sure the first coat is dry before applying the second coat. When you finish, wash your brush well, particularly down by the ferrule, or you will ruin it. That's why it's best to use an older brush.

STEP 3: *Paint Background Mountain Area and Create Atmospheric Perspective*

Start the background by painting a little sliver of sky in the upper left-hand corner with a mixture of white, Ultramarine Blue and Cerulean Blue. Then begin work on the mountain slope by scumbling in a mixture of white, Ultramarine Blue and a touch of Phthalo Blue for the snow areas. Allowing the gray gesso to show through in places, brush your strokes at an angle to define the slope of the ridges. This whole area will be very loose because it is too far away to show any detail.

Next, begin to develop the idea of rocks and trees on this distant slope. Using a mixture of Payne's Gray, Burnt Umber, Ultramarine Blue and a touch of Magenta Deep,

begin to brush in darker areas for rocks, thinking about the lay of the slopes. Then using the same paint, create the look of distant trees by using the point of your brush to push up little pyramids.

Because the mountain slope is in the distance, you need to create atmospheric perspective. As objects recede into the distance, they become more hazy and subdued, taking on a bluish cast. Create this effect by adding a wash over the entire area with the large mop brush, using white, Ultramarine Blue and Phthalo Blue. Use a palm-sized foam sponge to smooth out the wash.

STEP 4: *Paint Foreground Ground Cover*

Although I prefer to work from back to front on a painting, here we will take advantage of the main elements still being masked to go ahead and paint a ground cover of needles, sticks and rocks in the foreground. As I was reviewing my photos of ground cover, I came across one of pine tree roots intertwined with needles and other debris. I decided to sketch the roots in the lower right-hand side and then mask them. Now you're ready to use the Funny Brush technique for doing ground cover. Remember to keep your strokes and scumblings small because the viewer is a little distance away. Also spatter a little Unbleached Titanium White with a toothbrush to give some added texture.

Remove all the masking so you can better visualize the placement and size of the main elements. I use my fingers to rub off masking fluid. Masking fluid was really developed for use with thin watercolors. Since acrylic has some thickness to it, the edges may not peel off cleanly. If this happens, gently use the edge of a razor blade to clean them up, then go back and redefine the edges with your neutral gray gesso.

After completing the initial Funny Brush stage, work back into that area, defining shapes of rocks, logs and sticks suggested by the textures. Use a pointed round brush with Burnt Sienna, Yellow Ochre and white to do some cross-hatching strokes to suggest pine needles. Don't get too fussy. Just give a hint of these needles. The foreground is very monochromatic at this stage. We will add interesting shadows and other elements later.

STEP 5: *Create Backlit Distant Pines, Backlit Overhead Needles and Aspen*

Mask the standing wolf and the edges of the rocks again so that you can paint the trees in the middle ground. If you don't do this you will have to physically stop the paint where the edges meet. There always seems to be an unnatural buildup of paint when you do this. I prefer the flowing, continuous look I can achieve by masking. The pine trees on the left were painted first with white gesso. Use a ¾-inch (20mm) flat rake brush turned sideways to create the look of spreading pine branches. (Rakes are thinner than most brushes and the hairs tend to separate into sections like a garden rake, making them great for all sorts of textures.)

When this is dry, wash in Yellow Ochre, but not all the way to the edges. Then do a wash of Hooker's Green, then again with a mixture of Hooker's Green and Payne's Gray, continually working into the interior of the trees. Use the same technique for the overhead pine needles using a round brush, pushing out with the hairs of the brush for the needles. For the aspen leaves, dot white circular patterns first, then add washes of Yellow Ochre in varying degrees, leaving some areas almost white.

The aspen trunks are done by first painting them lightly with Burnt Umber. Then using a flat brush, paint thin white strokes. Use a sideways movement across the trees to create the roundness of the trunks. Repeat this process until you achieve a solid look.

STEP 6: *Determine Light Direction and Finish Aspen, Grass and Pine Bark*

It is important to define your light source early in the painting. To determine the light direction, I used the photo of the standing wolf as my light-source indicator. The photo clearly showed well-defined shadows coming at an angle from his feet going to the left. I carefully match all shadows and highlights throughout the painting to this model.

To finish the aspens, continue brushing sideways, creating a lighter edge of white and Yellow Ochre along the right side to indicate the light source. Create the shadowed center area of the trunks with a wash of Payne's Gray, Ultramarine Blue and a touch of Phthalo Blue. Make the markings on the trees with a mixture of Burnt Umber and

Payne's Gray. Don't make these marks too dark; the trees are a short distance away. Be subtle.

Add some texture to the pine trees using the cellophane technique. Be sure to crumple your cellophane into smaller shapes because the trunks are far away. Add branches that will serve to direct the eye back toward the standing wolf.

For the grass, paint first with Yellow Ochre and then use the Funny Brush to suggest grass texture. Use Payne's Gray, Burnt Umber and Phthalo Blue for the shadows. Create individual grass blades with white and Yellow Ochre, using a sharply pointed round brush. Keep your arm and wrist loose, and don't press too hard as you draw the blades. Paint dots at the top of the blades to suggest seed heads.

STEP 7: *Lay In the Rocks*

Transfer the outline of the rocks from your drawing to the painting. Mask areas that are on or near the rocks to keep them clean. Use the cellophane technique, carefully observing your references and always remembering your light source. Mold the cellophane to the planes and contours you want to produce. Continue working into the rocks, adding washes and creating cracks and shadows.

STEP 8: *Paint Roots and Lay In Shadows*

Begin working on the dead roots at the lower right with Payne's Gray and Burnt Umber. Then, using the dry-brush technique, stroke in white. Carefully follow the contours of the roots, leaving some of the underpainting showing through for cracks.

To give depth and dimension to the fore-ground, lay in shadows of Payne's Gray and Ultramarine Blue. Again, pay attention to your light source and think about the way sun filters through tree limbs and leaves. Bring up highlights in dappled areas with a mixture of Yellow Ochre, Burnt Sienna and white. Don't make your shadows too dark.

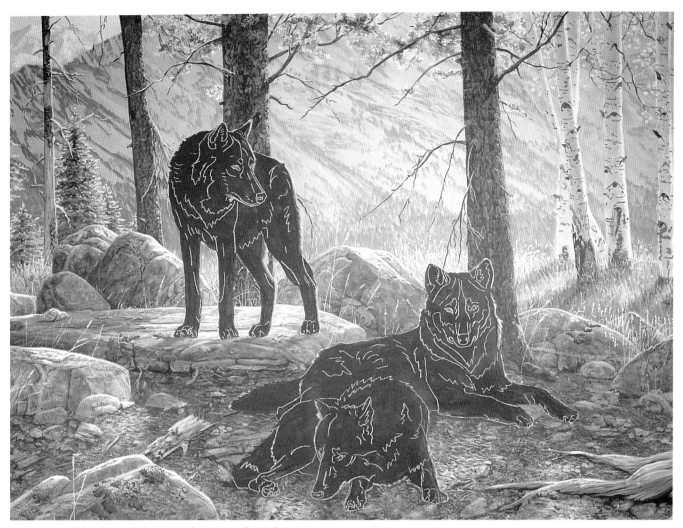

STEP 9: *Add Moss, Close Lichens and Wolves*

Add a few patches of moss on several rocks using the moss technique. Because the moss is small and far away, be sure to select a small, textured sponge with a very closely packed texture and use a very light hand to dab on the paint. Highlight the moss where the sun hits it with the tip of a round brush, using a strong mixture of Cadmium Yellow and a touch of white. Notice how placing moss throughout the painting keeps your eye moving from one bright green hump to the next. To paint the lichen, begin by underpainting the nearby rock with Payne's Gray. Then, using a coarse, "furry" textured sponge, dab on a mixture of Phthalo Blue, Phthalo Green and Payne's Gray.

Now it's time to paint the wolves. You'll use the techniques from chapter two for the eyes, noses, fur and paws. Start by masking the areas on the wolves where light will be shining through the fur; they should be a clean, neutral gesso. Then underpaint all three wolves with a mixture of Payne's Gray and Burnt Umber. Flip the drawing over the painting and, using transfer paper, transfer the details of the wolves onto the underpainting you've just done.

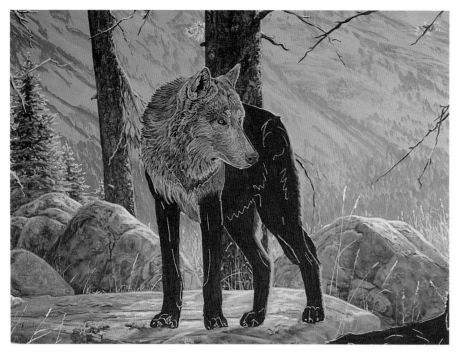

STEP 10: *Add Fur Details*

Rub off the masked areas around the highlighted areas. Feather a little Burnt Umber into these areas to suggest fur. Next, start painting the eyes and nose of the first wolf. When there is more than one subject, I like to complete one animal before moving on to the next, but doing the same step on each animal before moving on to the next step also works.

After painting the eyes and nose, detail the undercoat of the hair by using an old splayed round brush and Unbleached Titanium White. Yellow Ochre mixed with white works as well. When the subjects are relatively small, as in this painting, I use a no. 2 brush. If the subjects are larger, I use a larger brush. Begin at the nose and work back to the tail. Keep in mind the length of the hair in certain areas. Remember that the hair is very short on the face and legs.

STEP 11: *Refine the Fur With Washes*

Once you have painted the hair coat completely, add highlights with an opaque mixture of white and Yellow Ochre. You want these areas fairly bright, so apply several coats of paint. Then add a wash of Cadmium Orange over these light areas. Next, wash the main body area with Burnt Umber. This wash should not be too heavy; notice that you can still see the hairs through it. Here I have done only half the wolf with the wash so that you can see the progression.

STEP 12: *Finish Detailing the Fur*

Starting on the face, begin to detail the finished fur. Here I have completed the head, neck and face. Keep your brushstrokes on short hair areas soft by making your paint mixture fairly thin. Water will make the edges of your strokes blur slightly. Later, when you want more stiff, detailed-looking hair on the longer part of the coat, add less water.

Look for subtle colors to add depth and interest. One of my favorite combinations is Yellow Ochre and Phthalo Blue, which I use mostly in washes on white areas of the animals to create a reflected light in shadow areas. Use these procedures to complete the rest of the wolf.

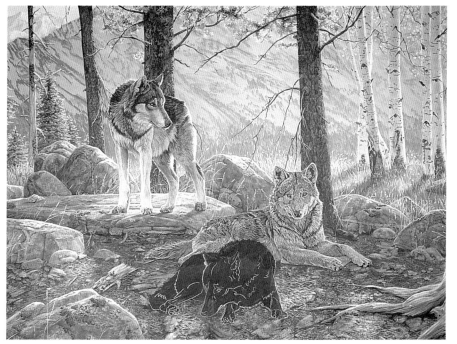

STEP 13: *The Wolves in Three Stages of Progress*

This illustration shows the three wolves in various stages of progress. The standing wolf is finished; the fur of the reclining wolf is drawn with Unbleached Titanium White; the wolf in the foreground is still just a drawing that has been transferred to the underpainting.

It is helpful to look at your painting in a mirror several times during its development. Looking at it in reverse will highlight any trouble areas, especially in anatomy. Continue painting the remaining wolves in the same manner as the standing one to complete the painting (the finished version appears on pages 88-89).

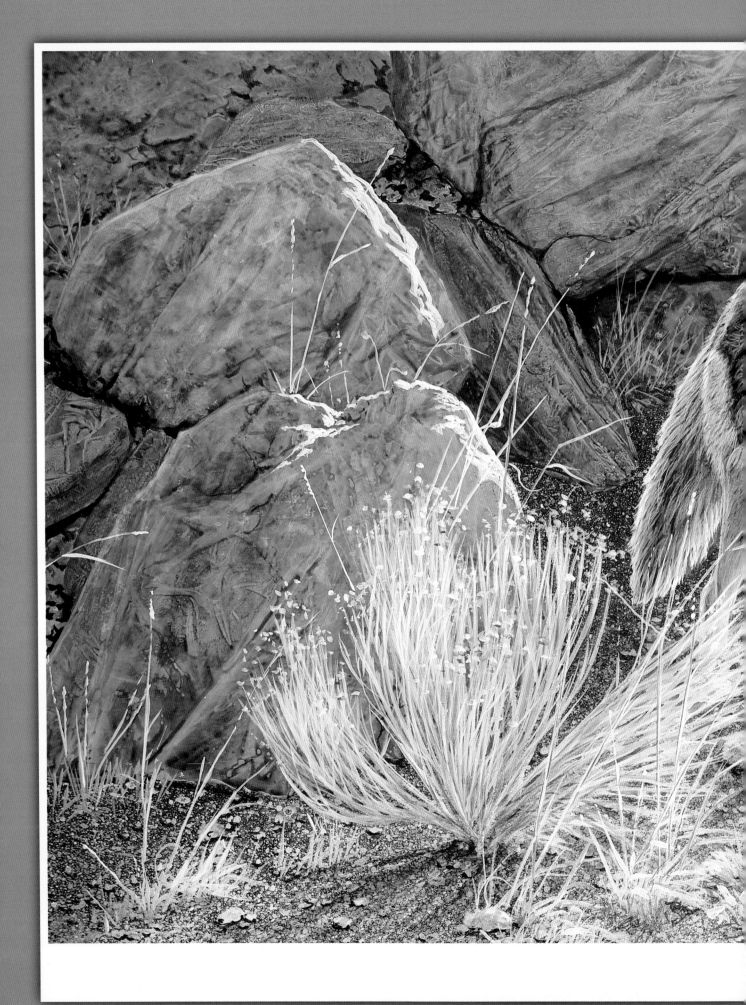

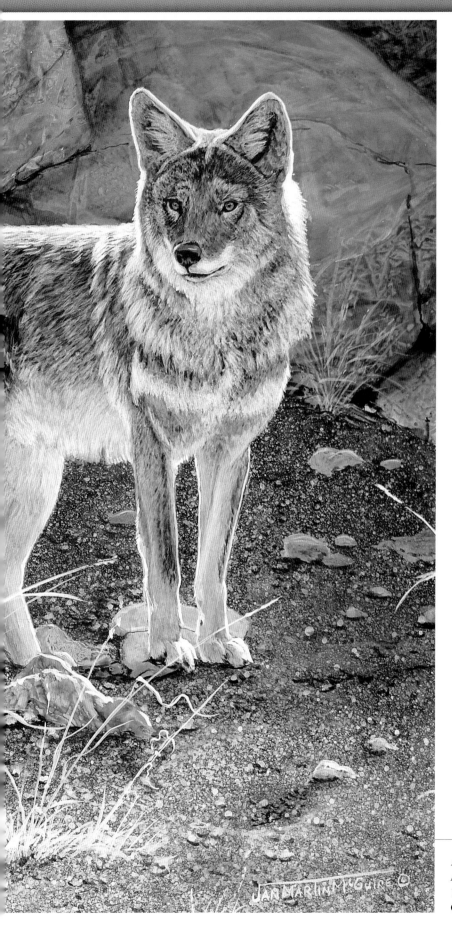

PAINTING
A COYOTE

In this chapter, we will combine the
habitat mini demonstrations of rocks
and dirt with pebbles to create a sandy,
desert-scrub setting for a single backlit
coyote. As in the previous chapter, I
will take you through my reference-
gathering stage and show you my
thumbnail sketches. In this demonstra-
tion, however, we will use traditional
thumbnail sketches rather than cutouts
to arrange the final drawing.

Morning Moment
Acrylic and Chromacolour on Masonite
12" × 16" (30cm × 41cm)
Collection of the Al Allred Family

Research

Research should be an ongoing process. Read, sketch, photograph and study nature at every opportunity. I am always gathering materials that I store in file cabinets, bookcases and sketchbooks. I pull them out, sometimes many years later, to assist in doing a painting.

Working From Taxidermy Mounts
I have been gathering and filing reference materials for over twenty years. Here I am (at about the age of twenty) sketching a mounted coyote at the Smithsonian in Washington, D.C. Taxidermy mounts can be useful, but the anatomy is not always perfect (especially in mammals). It is best to work from mounts found at major museums rather than from a local taxidermist, unless you're sure he or she is an award-winning expert.

Research at Zoos, Wildlife Parks and Rehabilitation Centers
Zoos and wildlife parks are particularly useful. While it is wonderful to be able to study animals in the wild, it is often hard to get good photos or sketches because wild animals tend to be skittish and elusive. Some facilities may permit artists to get closer than the general public. This is particularly helpful in photography where it might be difficult to focus through a fence. Always offer a donation for this privilege.

Gathering Habitat References
This is Yellowstone, a wildlife artist's dream and a great place to observe coyotes in the wild. Habitat photos are much easier to obtain than photos of wildlife. I have found that a landscape photo has inspired some of my best paintings. Don't be cheap: Shoot lots of film, especially if you are just beginning to build your reference files. Slides are cheaper than prints, but I find slides difficult to work from. I like to tape photos around my painting while I am working so I can move my eyes from one to another as needed. Inexpensive recognized label film can be purchased in bulk from discount clubs or in bulk from photography catalogs.

Thumbnails

These are traditional thumbnail sketches. Done quickly, they help the artist visualize composition alternatives. They are very simple, rough sketches and are usually anywhere from 1" × 2" (2cm × 5cm) to 3" × 5" (8cm × 13cm).

These are thumbnail sketches for *Morning Moment* (pages 104-105). I knew I wanted a backlit coyote in a rocky Southwest desert setting. For the most dramatic backlighting, it is best to place the subject against a darker background, so I am experimenting with the placement of the rocks. I often contrast light against dark, dark against light, warm against cool or cool against warm to give my paintings visual impact.

I am also playing with different positions for the coyote. It is more interesting to place the main subject somewhere other than the middle of the painting. There are several somewhat complicated formulas for determining the best placement, but the simplest is to divide your painting into fourths. Place the face or other important element in the middle of one of these quarters, as shown in the sketch at left.

A Coyote in a Rocky, Sandy Environment

Now we will paint a coyote in a rocky, sandy scene. After you've done the sketch as you did in the last chapter, transfer it with transfer paper, then mask out the coyote. Begin by laying in the background, which in this case consists of the rocks.

TECHNIQUES

Used in Previous Mini-Demos
Rocks (pages 72-73)
Dirt, sand and pebbles (pages 78-79)
Fur (pages 44-45)
Eyes (pages 39-41)
Nose (pages 42-43)
Paws (pages 46-47)

New Techniques
Single brushy plant
Strongly backlit subject

Step 1: *Lay In the Rocks*

Lay in the rocks using the technique from pages 72-73. Use a basic combination of Burnt Umber and Payne's Gray, but for some of the rocks in the shadowed background, mix Magenta Deep and Ultramarine Blue into your paints. Watch for these subtle colors, which will give depth, vibrancy and realism to your work. Remember not to let your mind tell you what color something is.

Step 2: *Create Details in the Rocks*

Develop roundness or flatness in your rocks by laying on washes of white to suggest the subtle reflection of light. Add washes to the two rocks in the foreground, as well as to the left side of the middle rock in the back, to simulate the effect of reflected light. On these rocks also add washes of Cadmium Orange, Flesh Pink and Burnt Sienna to give a glow where sunlight slants through and bounces back onto them. Paint the bright highlights on the rocks with white, Flesh Pink and Yellow Ochre. It may take several applications of paint to get these to "pop." Rocks that are in shadow may be pushed back with washes of Payne's Gray and/or Ultramarine Blue. Let the cellophane guide you when adding cracks and shadows for bumpy portions of the rocks.

12" × 16" (30cm × 41cm) untempered Masonite panel gessoed with neutral gray

Tracing paper, 12" × 16" (30cm × 41cm)

Mechanical pencil

Masking tape

Masking fluid

White Saral transfer paper

Liquid soap (to protect brush when applying masking fluid)

Various sizes of round brushes, from no. 2 to no. 14 (some frayed, some with good points)

Flat brush such as a ¾-inch (20mm) rake

Cellophane

Toothbrush

Newspaper

Gesso for white

Colors

(Liquitex acrylics or Chromacolours. I used Chromacolours.)

Burnt Sienna

Burnt Umber

Cadmium Orange

Flesh Pink

Hooker's Green Hue

Magenta Deep

Payne's Gray

Ultramarine Blue

Unbleached Titanium White

Yellow Ochre

STEP 3: *Paint the Dirt, Pebbles and Sand*

Refer to pages 78 and 79 to create the dirt and pebbles. Remember that this is a messy technique. Use newspapers, masking tape and masking fluid along edges, if necessary, to cover the area of your painting that you don't want spattered. Here I have covered the rocks; the coyote is still covered by the initial application of masking fluid. I also cover my reference photos with clear sheets of acetate so that I can still see them but they don't end up polka dotted.

Using a toothbrush, spatter Unbleached Titanium White over the whole area. (You can also use white mixed with Yellow Ochre.) Wash the entire area with Burnt Umber and repeat. You can repeat these two stages until you feel you have captured the correct look for the sand and dirt. The paint and bumps will build up with each layer. Too much buildup may be distracting to the viewer. If this happens, gently sand down the bumps with very fine sandpaper or use the edge of a razor blade to carefully remove them. You can create small pebbles by rapping a loaded brush against another brush as described on page 79.

STEP 4: *Add Shadows and More Small Rocks*

Since you want an area with very distinct shadows and sunlight, spatter brighter white (with a touch of Yellow Ochre) onto the foreground before removing the newspaper, masking tape and masking fluid. To create the shadow area, add a wash of Magenta Deep and Ultramarine Blue. These colors will give vibrancy to the shadows. In photos, shadows tend to look dark and dead. Observe them carefully outside, looking for subtle colors and reflected light.

At this stage, remove all the coverings of newspaper, masking tape and masking fluid. Note how all the elements look in relation to each other, then add rocks and individual pebbles.

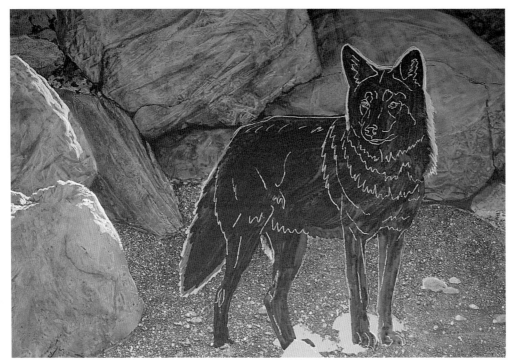

STEP 5: *Lay In the Coyote*

Because this is a strongly backlit subject, you want to maintain the clean, neutral color of the gessoed board in areas where sunlight will be shining through fur. Use masking fluid to mask these areas around the head (particularly the right side of the head and neck), the legs (particularly the back hind leg) and the tail. Now, using the fur technique demonstrated on pages 44-45, lay in the basic ground color of Burnt Umber and Payne's Gray. After removing the masking fluid, feather a little Burnt Umber into the area to suggest hairs. Be careful not to cover the whole area; just hint at the hair.

Flipping the map drawing back over the painting, use transfer paper to trace the drawing onto the underpainting of the coyote.

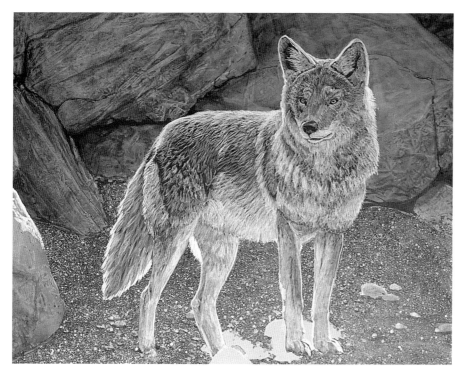

STEP 6: *Detail the Coyote*

After painting the eyes and nose, begin drawing the fur as demonstrated with the wolves in chapter six. Remember that the farther away the animal is from the viewer, the less actual detail will be seen. In other words, in this painting you shouldn't see individual hairs, but you will get the illusion of individual hairs because of the way these initial brushstrokes are laid in when using a splayed brush. Think groups of hairs and hair tracts.

STEP 7: *Finish the Fur*

Use Burnt Umber to wash the entire coyote, except in the highlighted areas. Wash the highlighted areas with Cadmium Orange. Remember to always use clean water for washes. Now detail the fur as we did on page 102 by starting on the face and working toward the tail. Use subtle colors, such as blue-gray, for hairs in shadow areas and Yellow Ochre washes under the chin and belly to simulate reflected light bouncing up. Use pure white to create the bright highlights along the neck to the right and under the thigh of the back leg. Don't obliterate the glowing orange; be sure to leave some along the edge. White never covers well, so you may have to do this a couple of times to get the brilliance you want.

Remember that strong backlighting can be tricky. If you outline the animal, it will look cut out and pasted on. Leave some edges soft and lost against the background so that they blend in.

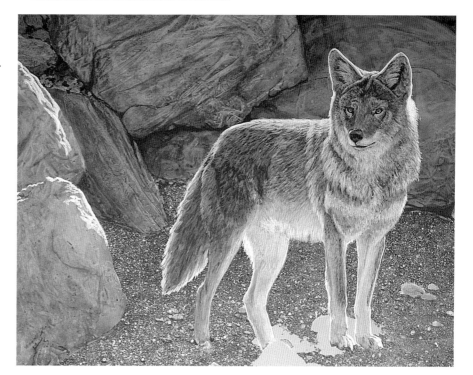

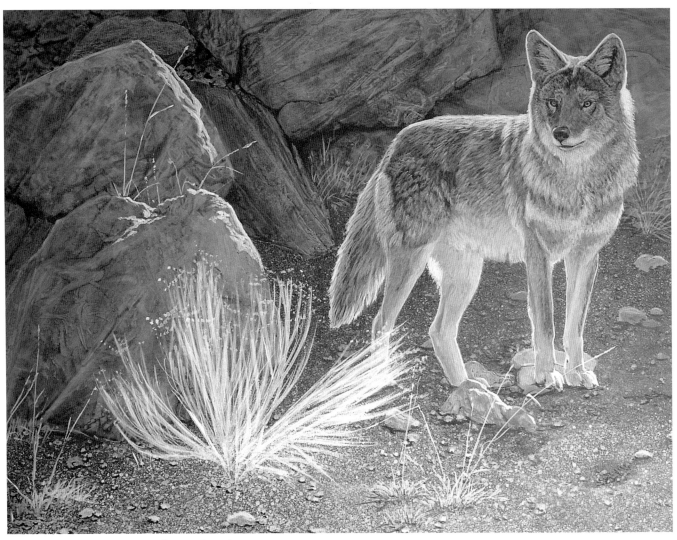

STEP 8: *Add Grasses and Sagebrush*

For the sage plant, use a flat ¾-inch (20mm) brush. Because you want light to glow through the backlit plant, first paint it in pure white. Using the edge of the flat brush, gently brush upward and outward, following the way the multiple stems grow. Don't overdo it; leave some light areas showing through. Turn the brush flat and gen- tly dab on some little round flowers on the stem tops.

Overlap some of the sage plant and single grasses across your subject to help it become an integral part of the painting. Also add some grasses from off the panel to create the illusion that the scene actually continues out- side the edges of the painting.

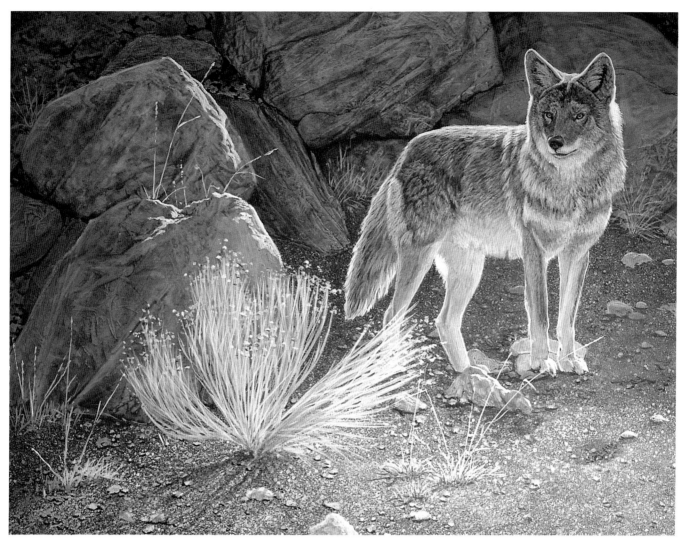

STEP 9: *Finish Detailing the Sagebrush Plant*

Add a light wash of Yellow Ochre and Hooker's Green over the plant. Don't add white to this wash or you will kill the vibrancy of the light playing through the plant. Using a small pointed brush, keep working in details with white lines that suggest the stems in more detail.

Emphasize some of the tiny flowerheads by dotting on Yellow Ochre and white. Add tiny bits of Burnt Umber under a few to give more definition. Be careful and don't overwork. These little flowers are too small and far away to have much detail. You only want to give the impression of detail.

Poke some holes through the sagebrush with a mixture of Payne's Gray and Burnt Umber to give depth. Also create a shadow under the plant with a wash of Payne's Gray. Pay attention to the direction of the sun, the lay of the land and any rocks the shadow may fall across. Work thinly and lightly. It's easier to go back and darken a shadow, if necessary, than to try to lighten one that's too dark or heavy.

Keep working back into the sage, creating shadows and details. Finish the painting by adding little touches here and there such as additional grasses. The finished painting appears on pages 104-105.

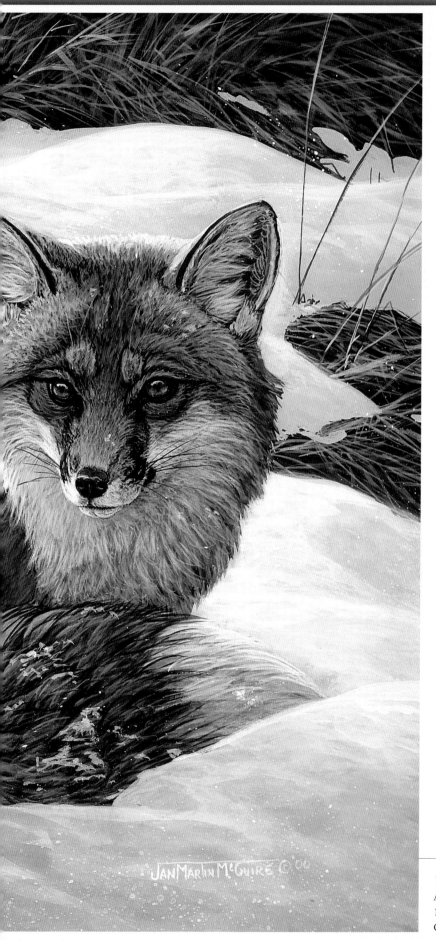

8

PAINTING
A RED FOX

You have now created two paintings in
which the subjects were distant, with quite
a bit of the environment visible around
them. In this painting of a red fox, we will
tighten our focus to illustrate that you can
create a sense of place and habitat even
when your subject is closer to the viewer.
This demonstration will allow you to see
techniques for depicting fur, eyes and noses
close-up. You will also incorporate tech-
niques for nearby bunches of grass and
snow as demonstrated in chapter five.

Winter Rest
Acrylic and Chromacolour on Masonite
12'' × 16'' (30cm × 41cm)
Collection of Mark Borla

Research

As I've shown you in the previous two chapters, I research all my paintings carefully. This doesn't mean that I decide on a subject, then make plans to research that specific subject right then. Research is a continuous process. I take one or two major research trips a year, but I also take every opportunity I can to do research on a smaller scale. When traveling to exhibits around the country, I always try to stop at zoos or other facilities along the way. When I'm out driving, I stop the car continually to photograph interesting rocks, trees, lighting or other scenery. I try to have my camera and sketchbook with me at all times because I never know when I'll see something interesting. Always be prepared and keep your eyes open. Photographs and sketches you make now may be useful years down the road.

Volunteering at Zoos and Rehabilitation Facilities

This is Briar, a cross-phase red fox that was rescued from a fur farm. I have a permit that allows me to keep wild animals, which gives me a unique opportunity to observe them closely. However, you don't have to keep animals yourself to see them up close, nor do I recommend doing so. Volunteering is an excellent way to get some personal experience with a variety of animals. Being a docent at a zoo or helping at rehab facilities is an excellent way to become thoroughly acquainted with wildlife—and do a good deed at the same time.

Game Farms

Game farms are commercial enterprises where wildlife photographers can take pictures of wild animals in natural settings. It is difficult to get good photographs of truly wild animals, especially predators, because they are very wary of humans. At these facilities you pay a premium for the luxury of working with habituated animals acting naturally in realistic habitats. The price can be well worth the wonderful reference photos that you get. This photograph of me was taken at a game farm in Montana during a winter photo shoot.

Painting in the Field

As I've already mentioned, it is very important to spend time in the field. Try different areas at different times of the year. Here I am painting in Alaska during a workshop with artists John Seerey-Lester and Alan Hunt. This photo shows an older field setup I used in which the seat was attached to the easel. It didn't allow me to stand up to paint, however, so I switched to a standard French easel as shown on page 87.

Camera Equipment

I've talked about my art supplies thoroughly, but I haven't described another invaluable tool: my camera.

Photography plays a major part in the life of a wildlife artist. It is important to become proficient with a camera to get useful reference material for your paintings. It is especially important to become thoroughly familiar with any new camera equipment before taking a major research trip. I am constantly amazed when I'm with a group out in the field—sometimes very far from home, such as in Africa—that someone will have a brand new camera and spend the whole trip complaining because the equipment doesn't work the way it's supposed to. Take lots of shots at zoos or drive-thru parks months before any trip to make sure you know how your camera and lenses work.

Photography equipment is as varied and individual as artists' mediums and methods. Experiment with borrowed or rented equipment to find out what suits you. I shoot with two types of cameras. The first I've used forever, and it is still my camera of choice. It is an old, hard-bodied Minolta X700. It is a totally manual camera, although I do have an auto advance attached to it. The lens I use with this camera is a Tamron 60-300mm zoom that has a macro setting for close-ups of flowers, leaves and other details. I sometimes use a doubler—also called a 2X teleconverter. This requires a lot of light and almost always should be used with a tripod. The Minolta is a workhorse and takes the best landscape pictures, particularly under tough lighting conditions such as backlighting.

As my eyes get older I find it tougher to focus the camera in some situations (such as moving animals), so I also use a Canon EOS RebelX with a 75-300mm zoom lens. I use a doubler with this camera as well, even though it can be difficult to focus.

I still believe simple is better. Fancy electronic cameras are sensitive to heat, cold, dust, jarring, bumping and all the things that go with field photography. When selecting equipment, thoroughly discuss your needs with a camera expert. You don't have to spend a fortune on lenses—unless you want to. A good zoom lens will give you the flexibility to shoot close up as well as far away without constantly changing lenses. I have found in over twenty years of experience that 300mm lenses give me wonderful reference photos.

Whatever you do, always take more than one camera body, several lenses, lots of film and extra batteries. I shoot 200 ASA print film almost exclusively. It is a good all-around film for most lighting situations.

My Photography Equipment

Minolta X700 (auto advance attached) with Tamron 60-300mm zoom lens and a sun hood

Minolta 2X teleconverter

Canon EOS RebelX with Canon 75-300mm zoom lens

Vivitar Series 1 2X auto focus teleconverter

Padded photographer's backpack

Photographer's vest (invaluable for carrying items you need at your fingertips, including binoculars, field guides, sketchbook, lip balm, bug spray and film)

200 ASA print film

Tripod (I have several cheap, lightweight ones)

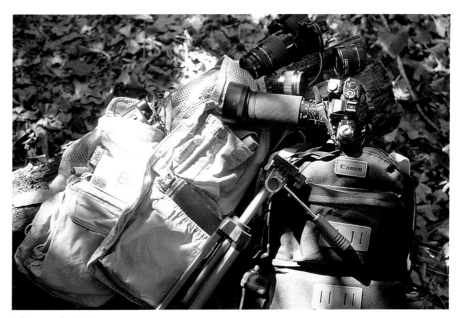

Photography Equipment
This photo shows most of the camera equipment I use for field photography. There is no need to spend a fortune. Look for used equipment or try renting, particularly lenses. Start with the basics and add accessories as necessary. Also consider taking a photography course at a local college or photo shop.

A Red Fox in a Close Snowy Scene

Follow the preliminary steps for creating thumbnail sketches or cutouts, transferring the final drawing to your painting surface and masking the main subject as outlined in the previous demonstrations. We will begin this painting at the stage of laying in the background elements.

TECHNIQUES

Used in Previous Mini-Demos
Bunches of grass
 (pages 82-83)
Snow (pages 84-85)
Fur (pages 44-45)
Eyes (pages 39-41)
Nose (pages 42-43)

Used in Previous Full Demos
Single blades of grass
 (pages 99 and 112)

STEP 1: *Create Depth Even in a Close-Up*

I've already done the preliminary work here, including masking the red fox with cellophane, tape and masking fluid. Even though this scene is a close-up, you still want to give it some depth. Begin with the background in the upper left corner by painting in an underpainting of Burnt Umber and Payne's Gray. Next, use the Funny Brush technique to create the beginning organic textures of hummocks of fallen-over grasses.

12" × 16" (30cm × 41cm) untempered Masonite panel, gessoed with neutral gray

12" × 16" (30cm × 41cm) tracing paper

Mechanical pencil for creating the map drawing and transferring to the board

White Saral transfer paper

Masking tape

Masking fluid

Liquid soap (to protect brush from masking fluid)

Various round brushes ranging from no. 2 to no. 12 (some with good points, some frayed)

Mop brush

Toothbrush

Funny Brush

Newspaper to cover areas when spattering

Gesso for white

Colors

(Liquitex acrylics or Chromacolours. I used Chromacolours.)

Burnt Sienna

Burnt Umber

Cadmium Orange

Flesh Pink

Magenta Deep

Payne's Gray

Phthalo Blue

Ultramarine Blue

Unbleached Titanium White

Yellow Ochre

STEP 2: *Refine Grasses and Create a Sense of Distance*

Continue working the grass area by painting in some individual blades using Yellow Ochre and white. Wash the entire area with Burnt Umber, then go back and redefine the grasses. Add more white and Yellow Ochre to the areas hit by the sun.

Paint some patches of snow using the snow technique. Because this painting will show the fox close up, there should be more detail in the background than in the mountains shown in the demonstration in chapter six. Use a mop brush with washes of white over this detail to push back or kill the area to create a sense of depth.

STEP 3: *Work the Habitat Into the Foreground*

Lay in the grasses in the foreground, continuing to use the Funny Brush technique. A clean, gray area is needed to add grasses overlapping the background area that is already done. You could have masked the area prior to painting the grasses, but in this example, paint in the hummock shapes using neutral gray gesso. This will allow you to go back over the area and lay in the underpainting so that you can create texture with the Funny Brush. These hummocks are an important element in the composition. They repeat the rounded shape of the fox and its colors.

STEP 4: *Paint the Background Snow and Shadows*

Begin painting the snow by scumbling in a mixture of Ultramarine Blue with a touch of Magenta Deep. Create interesting hills and valleys in the snow. This is more visually exciting than just painting plain, flat snow. Also, remember that snow is rarely white. It will be pure white only where bright sun hits it.

The shadows from the grass are particularly important for depth and realism. They are painted with a mixture of Phthalo Blue, Payne's Gray and Magenta Deep. Make sure your shadows follow the shape of the snow. When you reach the snow-covered area in front of the fox, stop. You will need to place the fox before proceeding with the snow that overlaps his tail and to determine where his own shadow will fall.

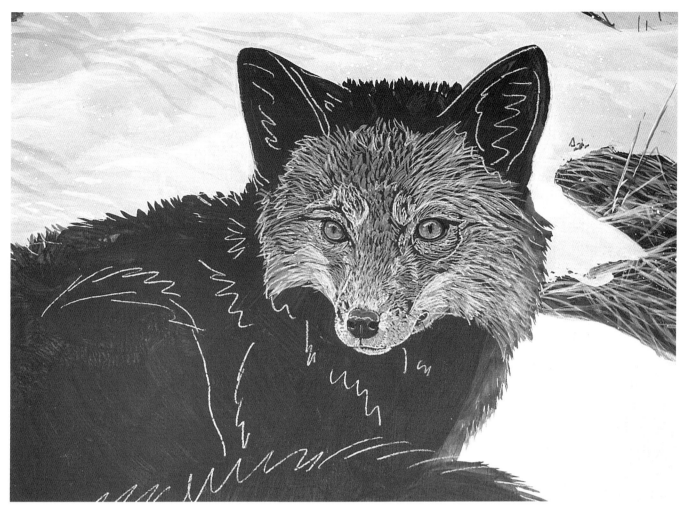

STEP 5: *Start the Fox*

After removing the cellophane and masking tape from the fox, begin the fur technique by underpainting with Payne's Gray and Burnt Umber. Because the animal is closer in this painting than in the other two demonstrations, we will pay more attention to detailing the eyes, nose and fur.

Transfer the drawing to the panel with Saral transfer paper, then begin the eyes. If the fox were turned so that the sun was hitting its face, you would need to underpaint the eyes with neutral gray. But because the fox is backlit and the foreground is in shadow, use the darker underpainting that you already have. The eyes should not be overly bright or sparkly. Paint the eyes using a mixture of Yellow Ochre and Burnt Sienna. Paint the gentle curve of light across the top of the eye using a mixture of Ultramarine Blue, white and Payne's Gray. The highlight

on the eye on the left may be a little brighter because that side is getting a bit more sun. Add shadows under the eyelids, but don't make them too heavy; the sun is not casting enough light in this area to create strong contrasts.

Next, paint the nose. The eyes and nose give life to the painting and will provide a "hook" for you to work from as you add the fur.

Draw the fur using Unbleached Titanium White. Pay particular attention to the length of the hair: very, very short on the nose and around the eye, gradually growing longer on the cheeks. Remember to look for hair tracts. Give character to the facial expression by emphasizing the eyebrows. At this stage, begin to differentiate the white markings by using heavier strokes in those areas.

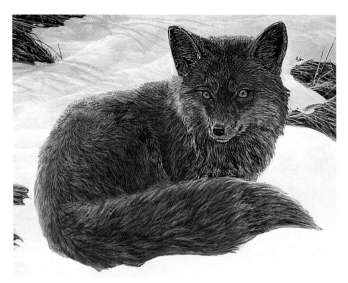

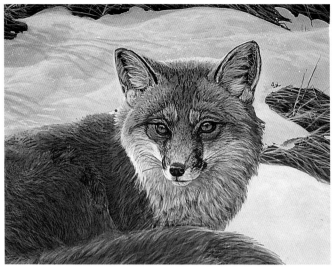

STEP 6: *Continue Painting the Fur*

Finish drawing fur on the entire fox with Unbleached Titanium White. Arrange the fur in V's across the haunches where it breaks over rolled and bunching muscles. When painting the tail, think of the thin, skin-covered bone in the middle of the tail from which the hair radiates. The hair grows in several directions, yet it follows the general lay of the tail. This will be further emphasized later when you detail the coat.

Do the unifying wash of the local base color. Because the fox's coat is so red, this wash should be a mixture of Burnt Umber and Burnt Sienna, not Burnt Umber by itself as in the previous demonstrations. In the areas directly in the middle, where the hind leg and front leg come together, add a wash of Magenta Deep. Use a wash of Burnt Umber and Ultramarine Blue for the white areas. Don't be afraid to wash over areas where you've just spent so much time drawing in all the details. You will still be able to see all the hairs. What you are doing is creating the illusion of depth in the fur.

Notice that we have not masked off any areas of the fur for backlighting as we did in the previous demonstrations. This is because the light in this painting is much softer and more subtle, and there aren't any areas where the sun actually shines through the fur.

STEP 7: *Finish the Face*

Now go back to the face and redefine the fur. At this point, don't try to paint each and every hair. If you do the coat will not look soft, but rather brittle and spiky. To avoid this, make sure your paint is very fluid. Experiment with how much water to add so that your brushstrokes will spread slightly. This will give the coat a softer look. Press harder on your brush to spread it out more where you want to simulate groups of hairs rather than individual ones. Use white, Yellow Ochre, Cadmium Orange (particularly where the sun hits the fur), Burnt Sienna and Magenta Deep in various combinations. For the white areas of the muzzle, throat and ears, use combinations of Ultramarine Blue, Payne's Gray and Magenta Deep.

Notice how I've achieved the effect of reflected light. Use some washes of Phthalo Blue mixed with Yellow Ochre. This glow is particularly evident on the left side of the face and under the chin in the finished painting. Look for subtle colors and highlights to add interest, especially on the face. Remember to include whiskers, which are particularly evident at this close range. Use Payne's Gray and a no. 2 round brush for the muzzle whiskers; for the eyebrow whiskers, use the same brush with white.

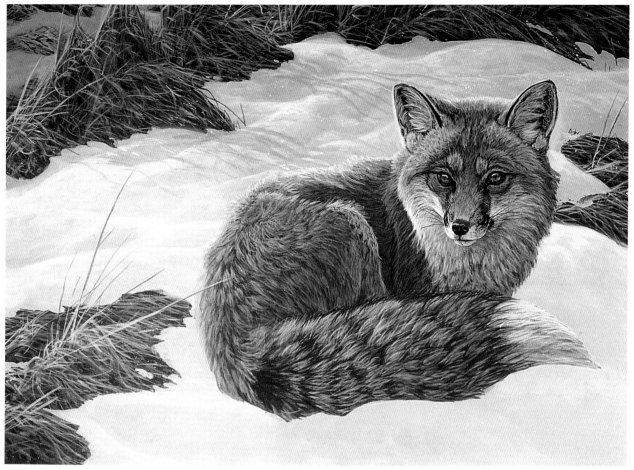

STEP 8: *Finish the Fur and Complete the Painting*

Continue working on the rest of the body using the same colors of paint. Notice, however, that there are fewer rich reds on the hindquarters and tail. Foxes typically have more grays and beiges from about mid-body back. Further define the V's for which you laid the foundation earlier on the rump and tail. Besides suggesting the underlying anatomy, these V's also help to create the illusion of wetness caused by snow melting from the fox's body heat. Use more Payne's Gray on the tail for the dark scent gland area and for the tips of the long guard hairs. Paint the white portion of the tail the same way as the throat.

Complete the painting by working the snow area, piling the snow up and around the fox, who has settled into it. Refer to the finished painting on pages 114-115. If the snow has a hard crust, the fox could lie right on top. But pushing the fox into the snow helps integrate him into the scene. For the same reason, pull some grass blades over him and across other areas of grass and snow as well. Use the tip of a somewhat frayed round brush to dab some snowflakes on the fox, particularly on the tail. Work back into the bright areas of snow with a mixture of white and a touch of Yellow Ochre. Now add spatters with a toothbrush using a mixture of white, Yellow Ochre and Flesh

Pink. Allow the spatters to fall on the fox and grasses for added texture and excitement.

When James, my partner and business manager, viewed this painting, he suggested adding a paw print in the snow. While it is possible that the fox stepped from the grass to the area he's in without leaving a track, a print does add interest. Always look carefully at your composition when painting snow. Ask yourself how your subject got to where he is. Would there be a trail? If so, it's important to include it. If the snow is deep, you don't have to make clear paw prints like those shown in this painting; you can simply make indentations. The trick is to make the inside of the tracks lighter than the surrounding snow.

Add some final washes of Burnt Sienna over most of the fox. Wash the highlights with pure Cadmium Orange. In the middle area of the body, do another wash of Magenta Deep to suggest a darker shadowy area. These washes help to quiet down and soften up the fur, which could look too choppy. Wash the highlights in the grasses with Cadmium Orange to match those on the fox. Remember that washes are wonderful for achieving subtle but effective changes in your work.

Sign and frame your painting. Enjoy.

Final Touches: Sign Your Name and Add the Copyright Notice

When you have completed the painting, sign your name with pride. Don't allow yourself to get carried away, however. The signature should not detract from the beauty of the painting itself. I suggest keeping your signature small, neat and subtle. Place it relatively low, in either of the lower corners. Try to select a location where your signature will show up if someone looks for it, but where it won't jump out at you from across the room. For my signature, I like to select a color that works with each individual painting, but I almost always sign in either white or Unbleached Titanium White.

On all my work, as on those of most professional artists, you will notice the copyright symbol, ©, after the name, usually followed by the date. Federal law automatically protects any work you create. However, to receive the full U.S. copyright protection, you must display this symbol in a location where it is clearly visible to the casual observer (in the case of two-dimensional art, on the front).

What does the copyright symbol signify? It means that no one may duplicate your original work by any means without your permission. This includes copying the image for use on greeting cards, T-shirts, prints, posters and so on. For more information regarding copyrights for the visual arts, contact the copyright office in Washington, D.C.

A Note on Using Artographs and Computers

Artists have always utilized a variety of tools to make their jobs easier. One such tool is the Artograph, which projects enlargements of sketches and photographs onto a wall. Another is the computer, which may be used as a composition aid. Reference photos can be scanned into a computer and, using software such as Adobe Photoshop, elements from these photos may be reduced, enlarged, reversed, relocated or combined with other images in many ways. Computer-aided composition is similar to the cutout process described in chapter six, but modern technology offers the artist more options.

Avoid becoming too dependent on reference photographs. The dangers of relying more on photographs than on your own eyes become even more pronounced when the photos are manipulated mechanically or electronically. Electronic flashes may produce artificial highlights and shadows. A reference photo with unnatural foreshortening resulting from the use of a telephoto lens may cause your drawing to look distorted and out of proportion. The danger that troubles me most, however, is that devices such as Artographs and computers may tempt artists to abandon the basics of drawing and simply trace or copy their reference photos. The old saying, "Use it or lose it," applies particularly to drawing, and I encourage you to draw as often as you can.

If you choose to utilize mechanical or electronic devices, use them carefully. I use my Macintosh (in my opinion, the only computer for artists) only to alter reference materials. I can enlarge or reverse images to fit my compositions and alter colors somewhat as well. Although a photo lab also can perform these functions, I find it more convenient to use a computer.

Appendix
Resources

Art Books
Drawing and Painting Animals

Adams, Norman and Joe Singer. *Drawing Animals.* New York: Watson-Guptill Publications, 1979. (highly recommended)

Bateman, Robert. *The Art of Robert Bateman.* New York: Viking Press, 1981.

Bateman, Robert. *An Artist in Nature.* New York: Random House, 1990.

Bateman, Robert. *Natural Worlds.* New York: Simon & Schuster, 1996.

Bateman, Robert. *The World of Robert Bateman.* New York: Random House, 1985.

Brenders, Carl. *Wildlife: The Nature Painting of Carl Brenders.* New York: Harry Abrams in association with Mill Pond Press, 1994.

Calderon, Frank. *Animal Painting and Anatomy.* New York: Dover Publications, 1975.

Ellenberger, W., H. Baum and H. Dittrich Baum. *An Atlas of Animal Anatomy for Artists.* New York: Dover Publications, 1956.

Isaac, Terry. *Painting the Drama of Wildlife Step by Step.* Cincinnati: North Light Books, 1998.

Knight, Charles R. *Animal Drawing, Anatomy and Action for Artists.* New York: Dover Publications, 1959.

Wilwerding, Walter J. *Animal Drawing and Painting.* New York: Dover Publications.

Wild Canids

Alderton, David. *Foxes, Wolves and Wild Dogs of the World.* London: Blandford, 1998; distributed in the U.S. by Sterling Publishers.

Bauer, Erwin A. *Wild Dogs: The Wolves, Coyotes and Foxes of North America.* San Francisco: Chronicle Books, 1994.

Turbak, Gary. *Twilight Hunters, Wolves, Coyotes and Foxes.* Flagstaff, Arizona: Northland Press, 1987.

Wolves

Dutcher, Jim and Richard Ballantine. *The Sawtooth Wolves.* Bearsville, New York: Rufus Publications, 1996. (highly recommended)

Lawrence, R.D. *Trail of the Wolf.* Emmaus, Pennsylvania: Rodale Press, 1993.

Mech, L. David. *The Way of the Wolf.* Stillwater, Minnesota: Voyageur Press, 1991.

Mech, L. David. *The Wolf: The Ecology and Behavior of an Endangered Species.* Garden City, New York: Natural History Press, 1970.

Rue, Leonard Lee III. *Wolves: A Portrait of the Animal World.* New York: Smithmark Publications.

Savage, Candace. *Wolves.* San Francisco: Sierra Club Books, 1994.

Wood, Daniel. *Wolves.* Vancouver, British Columbia: Whitecap Books.

Foxes

Grambo, Rebecca L. *The World of the Fox.* San Francisco: Sierra Club Books, 1994.

Henry, J. David. *Red Fox: The Catlike Canine.* Washington, D.C.: Smithsonian Institution Press, 1996.

Macdonald, David. *Running With the Fox.* New York: Facts on File, 1987.

Coyotes

Grady, Wayne. *The World of the Coyote.* San Francisco: Sierra Club Books, 1994.

Harrison, Philip L., ed. *Seasons of the Coyote: The Legend and Lore of an American Icon,* San Francisco: HarperCollins West, 1994.

Ryden, Hope. *God's Dog: A Celebration of the North American Coyote.* New York: Viking Press, 1995.

Wilkinson, Todd. *Track of the Coyote.* Minocqua, Wisconsin: NorthWord Press, 1995.

Wildlife Workshops

Beartooth School of Art, (406) 388-1000

John Seerey-Lester Studio Master Classes, (941) 966-2163

Research and Photography Facilities

I haven't visited all of these places, so I can't vouch for them personally. Call before you visit. Some have limited public access, and not all species may be on display at all times. Collections do periodically change. Many facilities allow special access for artists. The game farms make their living from photographers and artists, so there is a substantial fee.

Photography Game Farms

Animals of Montana, (406) 686-4979

Wild Eyes, Columbia Falls, MT, (406) 387-5391

Research, Rescue & Rehab Facilities
UNITED STATES

Candy Kitchen Rescue Ranch, Ramah, NM, (505) 775-3304. Timber wolves, wolf hybrids.

California Wolf Center, Julian, CA, (619) 234-9653. Timber wolves.

International Wolf Center, Ely, MN, (800) 359-9653. Timber wolves.

Lakota Wolf Preserve, Columbia, NJ, (908) 496-9244. Timber wolves.

Appendix

Mission Wolf, Silver Cliff, CO, (719) 746-2919. Timber wolves.

Wild Canid Survival and Research Center, Eureka, MO, (636) 938-5900. Timber wolves.

Wolf Education and Research Center (Sawtooth Pack), Nez Perce Reservation, Winchester, ID, (208) 924-6960. Timber wolves.

Wolf Haven International, Tenino, WA, (360) 264-4695. Timber wolf, tundra/arctic wolf, coyote.

Wolf Hollow, Ipswich, MA, (978) 356-0216. Timber wolves.

Wolf Park, Battle Ground, IN, (765) 567-2265. My favorite place. Timber wolves, coyotes, foxes.

CANADA

Call of the Wild, Haliburton Wolf Research, Markham, Ontario, (905) 471-9453. Timber wolf.

Zoos

EASTERN UNITED STATES

Brandywine Zoo, Wilmington, DE, (302) 571-7788. Red fox.

Bronx Zoo, Bronx, NY, (718) 367-1010. Timber wolves.

Elmwood Park Zoo, Norristown, PA, (610) 277-3825. Timber wolves.

Museum of Science Live Animal Center, Boston, MA, (617) 723-2500. Red fox.

Seneca Park Zoo, Rochester, NY, (716) 266-6591. Timber wolves, red fox.

Thompson Park Conservancy, Watertown, NY, (315) 782-6180. Timber wolves.

Virginia Living Museum, Newport News, VA, (804) 595-1900. Coyote, red fox.

ZooAmerica, Hershey, PA, (717) 534-3860. Timber wolves.

SOUTHERN UNITED STATES

Alexandria Zoological Park, Alexandria, LA, (318) 473-1143. Red fox.

Audubon Zoological Park, New Orleans, LA, (504) 861-2537. Red Fox.

Brevard Zoo, Melbourne, FL, (321) 254-3002. Red fox.

Grassmere Wildlife Park, Nashville, TN, (615) 883-1534. Timber wolves.

Limestone Zoological Park and Exotic Wildlife Refuge, Harvest, AL, (256) 230-0330. Coyote, red fox.

Memphis Zoo, Memphis, TN, (901) 276-9453. Timber wolf exhibit scheduled to open 2001.

Silver Springs Park, Silver Springs, FL, (352) 236-2121. Coyote.

MIDWEST UNITED STATES

Binder Park Zoo, Battle Creek, MI, (616) 979-1351. Timber wolves.

Bramble Park Zoo, Watertown, SD, (605) 882-6269. Coyote, red fox.

Brookfield Zoo, Brookfield, IL, (708) 485-2200. Timber wolves, red fox.

Cleveland Metroparks Zoo, Cleveland, OH, (216) 661-6500. Timber wolves.

Columbus Zoo, Powell, OH, (614) 645-3550. Timber wolves.

Como Park Zoo, St. Paul, MN, (651) 487-8201. Timber wolf.

Dakota Zoological Society, Bismarck, ND, (701) 223-7543. Timber wolf, coyote.

Dickerson Park Zoo, Springfield, MO, (417) 864-1800. Coyote, red fox.

Henry Doorly Zoo, Omaha, NE, (402) 733-8400. Timber wolves

Little Rock Zoo, Little Rock, AR, (501) 666-2406. Red fox.

Mesker Park Zoo, Evansville, IN, (812) 425-4344. Timber wolf.

Potter Park & Zoo, Lansing, MI, (517) 483-4222. Timber wolves.

Ralph Mitchell Zoo, Independence, KS, (316) 332-2513. Coyote, red fox.

Roosevelt Park Zoo, Minot, ND, (701) 857-4166. Timber wolves.

Safari Joe's Zoological Park, Sapula, OK, (918) 224-9453. Timber wolf.

Safari Zoological Park, Caney, KS, (316) 879-2885. Timber wolves, red fox.

Toledo Zoo, Toledo, OH, (419) 385-5721. Arctic/tundra wolves.

Tulsa Zoo and Living Museum, Tulsa, OK, (918) 669-6600. Timber wolf, tundra wolf.

WESTERN UNITED STATES

Alameda Zoo, Alamogordo, NM, (505) 439-4290. Coyote.

Arizona-Senora Desert Museum, Tucson, AZ, (520) 883-1380. Coyote.

Denver Zoological Gardens, Denver, CO, (303) 376-4800. Tundra/arctic wolves.

Folsom City Zoo, Folsom, CA, (916) 985-7347. Timber wolves, red fox, coyote.

Living Desert, Palm Desert, CA, (760) 346-5694. Coyote.

Los Angeles Zoo, Los Angeles, CA, (323) 644-6400. Coyote, red fox.

Northwest Trek Wildlife Park, Eatonville, WA, (360) 832-6117. Timber wolves.

Oregon Zoo, Portland, OR, (503) 220-2789. Timber wolves.

Phoenix Zoo, Phoenix, AZ, (602) 273-1341. Coyote.

San Diego Zoo, San Diego, CA, (619) 234-3153. Timber wolf.

Wildlife Safari, Winston, OR, (541) 679-6761. Timber wolf, red fox.

Woodland Park Zoo, Seattle, WA, (206) 684-4800. Timber wolves.

Zoo Montana, Billings, MT, (406) 652-8100. Timber wolves.

CANADA

Calgary Zoo, Calgary, Alberta, (403) 232-9300. Timber wolves.

Jardin Zoologique de Grandby, Granby, Quebec, (514) 372-9113. Tundra/arctic wolves.

Jardin Zoologique du Quebec, Charlesbourg, Quebec, (418) 622-0313. Timber wolves.

Magnetic Hill Zoo, Moncton, New Brunswick, (506) 384-0303. Tundra/arctic wolves.

Metropolitan Toronto Zoo, Toronto, Ontario, (416) 392-5971. Tundra/arctic wolves.

Parc Safari Africain, Hemmingford, Quebec, (514) 247-2727. Timber wolves.

Valley Zoo, Edmonton, Alberta, (403) 496-6912. Timber wolf, red fox.

EUROPE

Camperdown Wildlife Centre, Dundee, Scotland, 44-1-382-432-689. Timber wolves, red fox.

Palacerigg Country Park, Cumbernauld, Scotland, 41-1-236-720-047. Timber wolves, red fox.

Parc Zoologique de la Ville D'Amiens, Amiens, France, 33-22-43-06-95. Timber wolves.

Whipsnade Wild Animal Park, Dunstable, Bedfordshire, England, 44-1-582-872-171. Timber wolf.

Zoological Society of Ireland, Dublin, Ireland, 353-1-6771-425. Timber wolf, arctic fox.

Index

A

Anatomy, 24-25, 95, 106, 123
 coyote, 30
 red fox, 34
 wolf, 26
Anatomy and proportion, 18-47

B

Backlighting, 27, 98, 107,111, 112, 121
Body language, 53, 57, 58-59, 60

C

Canid, wild
 eyes, 38
 fur, 44
 muscles, 25
 nose, 42
 skeleton, 24
 social and family structure, 54
Colors, 15, 103
 local, 45
 reflected, 27, 36, 72, 73
 shadows, in, 27
Composition, 15, 93, 107, 120, 123, 124
Contrast, 107
Coyotes, 6, 7, 11, 12-13, 25, 26, 30-33, 54, 60, 61, 104-105, 108-113
 backlit, 107, 110
 reference photos, 30, 31-33

D

Demonstrations
 bark, 80-81
 coyote, 104-113
 dirt and pebbles, 78-79
 fox, 118-123
 grass, 82-83
 ground cover, 76-77
 moss, 74-75
 rock, 72-73
 snow, 84-85

wolves, 94-103
Demos, mini
 eyes, 39-41
 fur, 44-45
 nose, 42-43
 paws, 46-47

E

Ears, 20, 55, 57,59
Eyes, 20, 27, 28, 29, 35,36, 38, 39, 55, 56, 57,102, 121

F

Facial expressions, 53, 54, 55-57, 58, 121
Foxes, 6, 7, 8, 9, 11, 25, 34-37, 45, 54, 64-65, 114-115
 reference photos, 34, 35-37
Fur, 17, 23, 44-45, 46, 47, 102-103, 111, 120, 121, 122, 123
 depth of, 32, 36, 37, 44, 122

G

Grasses, 71, 82-83, 99, 112, 113, 199, 120, 123
Ground cover, 17, 97, 98

H

Habitat, 64-87
Hair, 19, 25, 27, 28, 31,57, 58, 95, 110
Head, 20, 27, 33
Howling, 27, 33, 50

L

Landscapes, 71
Legs, 20, 27, 33, 63
Lichen, 101
Lips, 55, 56, 57

M

Masonite panels, preparing, 92
Moss, 101

Mountains, 96
Movement, 62-63
Muscles, 59
 See also Anatomy and proportion
Muzzles, 20, 32, 33, 36

N

Nose, 20, 28, 42-43, 102, 121

P

Painting in the field, 86, 87, 116
Paw prints, 123
Paws, 20, 29, 33, 37, 46-47, 58
Pebbles, 71, 79, 109, 110
Photos, 86, 110, 116, 124
 See also References
Proportions, 22, 42
Pups, 10, 26, 39, 48-51

R

References, 42, 46, 81, 95, 106
 gathering, 90, 106
 habitat, 106
 limited, 27
 photos, 11, 31, 50-51, 68, 69, 70, 71, 72, 73, 74, 76, 80, 81, 90, 99, 117
Research, 11, 65, 90, 106, 116
 facilities, 21
 in the field, 86
Rocks, 64-65, 72-73, 95, 96, 100, 108, 110, 97, 100

S

Sagebrush, 112, 113
Scumbling, 46, 97
Shadows, 11, 27, 32, 37, 38, 41, 43, 72, 73, 76, 79, 99, 100, 110, 111, 113, 120, 121
 artificial, 124

light in, 73
 observing, 11
Sketchbook, 15, 21, 86, 106, 116
Sketches, 22-23, 71, 93, 107, 118
Sketching, 2, 21, 72, 74, 90
Snow, 71, 84-85, 96, 120
Snowflakes, 123
Social structure, 54

T

Tail, 20, 27, 31, 34, 58, 59, 123
Techniques, basic
 crosshatching, 97
 drybrushing, 17, 45, 100
 feathering, 102, 110
 Funny Brush, 76, 82, 97, 99, 118, 120
 list of, 108
 loaded brush, 79, 109
 paint handling, 16-17
 scumbling, 17, 76, 78, 80, 84, 96, 97, 118
 spattering, 97, 109, 110, 123
 toothbrush, 78
Texture, 17, 86, 71, 72, 73, 74, 75, 76, 78, 80, 81, 82, 84, 94, 97, 99, 118
Thumbnail, 93, 107, 118
Trees, 18-19, 95, 96, 98

W

Whiskers, 28, 122
Wolves, 1, 3, 6, 7, 10, 11, 18-19, 20, 25, 26-29, 48-49, 52-53, 54, 60, 61, 71, 88-89
 reference photos, 26, 27-29

Create extraordinary wildlife art
WITH NORTH LIGHT BOOKS!

Cynthie Fisher helps you paint realistic deer, antelope and more with straightforward instruction drawn from years of wildlife painting experience and zoological training. You'll find a detailed review of anatomy along with instructions for capturing the fine details of fur, antlers and facial features, plus proper use of color, texture, composition and light.

1-58180-021-5, paperback, 128 pages

Rod Lawrence provides you with the knowledge you need to paint over 15 waterfowl and wading birds, including mallards, white ibis, willets, heron, northern shovelers, Canadian geese and more. You'll master everything from avian body shapes and proportions to colors and habitats. Additional instructions help you reproduce realistic plumage.

1-58180-022-3, paperback, 128 pages

Make your wildlife paintings stand apart from the herd by capturing the fine details that give your subjects that certain "spark" they need to come to life. Fifty step-by-step demonstrations show you how to make fur look thick, give feathers sheen, create the roughness of antlers and more!

1-58180-177-7, paperback, 144 pages

Capture your favorite animals up close and personal-including bears, wolves, jaguar, elk, white-tailed deer, foxes, chipmunks, eagles and more! Kalon Baughan and Bart Rulon show you how, providing invaluable advice for painting realistic anatomies, colors, and textures in 18 step-by-step demos.

0-89134-962-6, hardcover, 128 pages

Through step-by-step demonstrations and magnificent paintings, Patrick Seslar reveals how to turn oils, watercolors, acrylics or pastels into creatures with fur, feathers or scales. You'll find instructions for researching your subject and their natural habitat, using light and color and capturing realistic animal textures.

1-58180-086-X, paperback, 144 pages

Discover a wealth of crisp, gorgeous photos that you'll refer to for years to come. Finding the right image is easy—each bird is shown from a variety of perspectives, revealing their unique forms and characteristics, including wing, feather, claw and beak details. Four painting demos illustrate how to use these photos to create your own compositions.

0-89134-859-X, hardcover, 144 pages